CHEDDLETON
& DISTRICT
THROUGH TIME
Neil Collingwood

For Ann

Enjoy the reminiscing

25th January 2019

AMBERLEY PUBLISHING

Acknowledgements

I would like to extend my thanks to the following, who have been of much assistance throughout the project: Iris Alcock, Pauline and Ray Allen, Christina and Stan Beardmore, Jayne Bloor, Roger Bold, R. and M. Bowker, Harry Burn, Christina Carr, Karen Clark, Kim Clowes, Alistair Andrew Collingwood, Rosemary Dale, Barbara Duffield, Marjorie Edwards, Geoff and Jean Fisher, Ralph and Irene Fletcher, Mr P. and Mrs M. Hall, Paul Harvey, Craig and Kerry Hodson, Joy Hodgkinson, Carl and Jill Keeling, Philip Kent, Christoph Krahenbuhl, Jeffrey Lowe, Andrew Molloy, Alison Parish, Mrs J. Peck, Irene Plant, Mr H. Scott-Moncrieff, Mrs N. Stanton, Ms Sylvia Thomas, John Tunna, Linda Wassall, W. C. Wilkes, Sir Charles Middleton and Peter Cordon, and everyone else from Cheddleton and Wetley Rocks.

With especial thanks to Sue Fox, who never fails to support me throughout all of my projects.

First published 2014

Amberley Publishing
The Hill, Stroud, Gloucestershire, GL5 4EP
www.amberley-books.com

Copyright © Neil Collingwood, 2014

The right of Neil Collingwood to be identified as the Author of this work has been asserted in accordance with the Copyrights, Designs and Patents Act 1988.

ISBN 978 1 4456 3395 4 (print)
ISBN 978 1 4456 3406 7 (ebook)

British Library Cataloguing in Publication Data.
A catalogue record for this book is available from the British Library.

Typesetting by Amberley Publishing.
Printed in the UK.

Introduction

The village of Cheddleton is located on the A520 (Cheadle Road) around 3 miles from Leek and 8 miles from Meir, which lies at the edge of the Stoke-on-Trent conurbation. People passing through the village by car probably notice a smallish ribbon settlement straddling the road for a distance of half a mile. They won't see the parish church, but may notice that Cheddleton, unlike a great many other villages today, possesses facilities such as a factory, restaurant, post office, pub, dentist, hairdressers, musical instrument shop, a 'one-stop shop', vet and a pharmacy. The fact that Cheddleton has all of these makes the village remarkable enough, and yet the true size and scale of Cheddleton has still escaped them.

Cheddleton has been put forward as the largest village in England, numerous times in the recent past. Rather like an iceberg in the ocean, much of Cheddleton and its extensive housing development escapes notice from the main road. The 2011 census recorded a population for Cheddleton of 5,444 persons in 2,267 households, which gives the village more than one quarter of the population of the nearby town of Leek, the administrative centre of the North Staffordshire Moorlands.

So how did Cheddleton come to be there, and what is it about the area that makes it worthy of a book like this one? Firstly, both Cheddleton (Celtetone) and Basford (Bechesword) appeared in William the Conqueror's Domesday survey of 1086; these two settlements at least have a very long history. The parish church of St Edward the Confessor contains masonry dating from the thirteenth century and possibly some from an even earlier church, so Cheddleton has certainly been at the centre of a parish for at least 700 years.

The presence in the village of an eighteenth-century canal, a nineteenth-century railway, a main road and a river have all played a part in making Cheddleton an important location in the area, and have massively contributed to the village's growth. Convenient transport links led to the utilisation of land and natural resources, and caused the population to grow further.

It was another nineteenth-century development that was perhaps most responsible for making Cheddleton famous, or some might say infamous. In the 1890s, it was realised that Staffordshire had inadequate facilities to deal with its lunatics (a perfectly acceptable description at the time), and so the site for a new asylum was sought. Various locations in North Staffordshire were looked at, with Bank Farm, between Leekbrook and Cheddleton, eventually chosen as the site. It was considered desirable that an asylum should be largely self-sufficient, and should be able to easily obtain things that it couldn't produce itself. The site chosen was located on farmland, meaning the hospital could produce its own food. It was also close to the North Staffordshire Railway's Churnet Valley line, and so coal and other consumables could be imported easily into the institution. An electric tram system was built to carry coal (and patients) right into the middle of the hospital. St Edward's Hospital opened

in 1899 and remained open for a century, housing many hundreds of patients at a time. Today, many of the old hospital buildings and a large proportion of the grounds have been converted into a housing development almost entirely hidden, as was the hospital, from the surrounding areas.

The presence of good transport links to the village also greatly aided the development of other activities there. The presence of the River Churnet meant that a mill could be operated to grind corn. later, a second mill – this one grinding flint – was built, and today the two mills are maintained in full working order, forming one of Cheddleton's two museums. The canal meant that mineral resources in the area could be exploited, and meant the Wall Grange Brickworks was able to produce the bricks that were used in the expansion of Leek and Stoke-on-Trent, and that built the asylum. The railway and its station meant that people and freight could travel in and out of the village easily. After the railway closed, the Churnet Valley Railway Co. took over the station and developed the site into a very large railway heritage centre running regular trains as far as Waterhouses, and it is still expanding.

Up until now, this introduction has concerned itself only with the village of Cheddleton but, as the name suggests, the book also covers other places in the district. Notable amongst these is Wetley Rocks, which is really more of a ribbon settlement than Cheddleton, constrained as it is on one side by the Millstone Grit cliffs that gave it its name. The rock from these cliffs was popular for building, and many people in Wetley Rocks would have been employed in quarrying it. The book also stretches to Wall Grange, Denford, Basford and Belmont.

The proliferation of the Sneyd family in the area resulted in a concentration of gentlemen's residences, and these houses have all survived and are maintained as family homes rather than as hotels or nursing homes. The Cheddleton Sneyds were a cadet branch of the Keele Hall Sneyds, and seem to have relished building themselves fine houses neighbouring those already occupied by other family members. Thus in the district, we have Ashcombe Park, Basford Hall, Belmont Hall, Sharpcliffe Hall and Woodlands, all of which were Sneyd homes at one time or another. The presence of these houses led to further development of the areas surrounding them in order to provide accommodation for estate staff. Included in this is even a miniature church at Belmont (Chapel House) that was never consecrated, and a farm that was converted into a pub (The Sneyd's Arms) at Basford Green. The Sneyd houses, together with others, have all been included in this volume.

So, if a traveller was to stop and look around the area, or even just to peruse this book, would they still believe that Cheddleton isn't much of a place, just an unimportant village strung along the A520? I think not, and if they did still believe that, I feel sure that the local people would soon put them right. The many favourable comments left by visitors to the museums and caravan park certainly show that those who have discovered the attractions of Cheddleton consider themselves to be lucky.

I would like to thank all of those from Cheddleton, Wetley Rocks and the surrounding areas who have helped me to put this book together, and if I have missed anyone, I assure you that it was unintentional and I unreservedly apologise.

Neil Collingwood, September 2014

Leekbrook

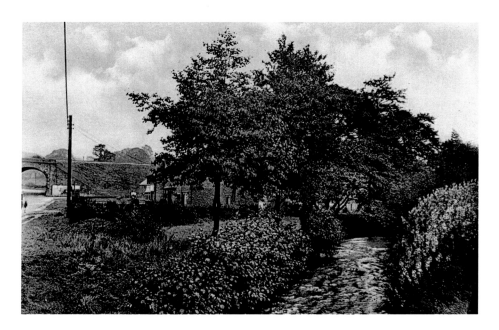

Cheadle Road, Leekbrook

This old photograph was taken looking along the brook that rises at Ashenhurst and flows rapidly down to join the River Churnet. Today, overhanging trees make it difficult to see the water, but the view along the road in the two photographs is comparable. Many more properties now stand between the brook and the end of Basford Lane and most, if not all, of the properties on the old photograph have been demolished, one very recently to allow an extension to Crown Garage.

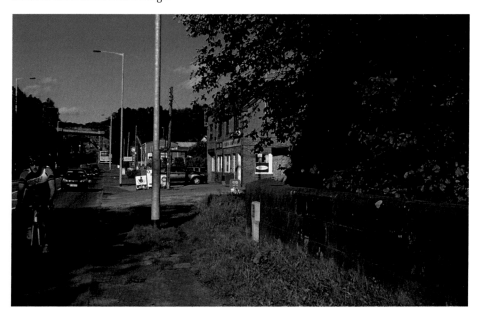

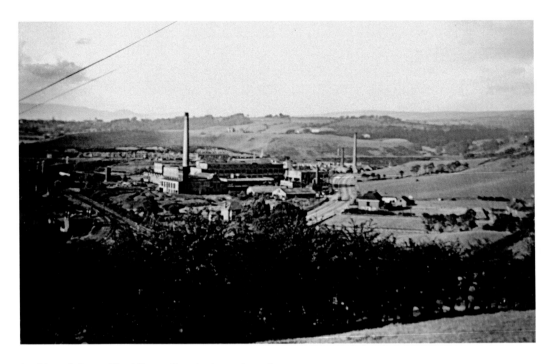

Leekbrook from Cheddleton Heath, August 1946

This panorama from near Cheddleton Heath House shows the vast changes that have taken place in the seventy years between the two photographs. Now gone is Joshua Wardle's huge dyeworks opened in 1830, and in its place is the Cheddleton Way housing estate. Beyond that is the Leekbrook Way industrial estate. The Traveller's Rest is common to both photographs, and would have been open for less than twenty years in the old photograph, having replaced its predecessor across the road in 1929.

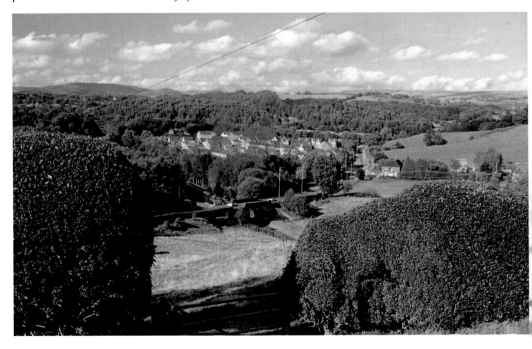

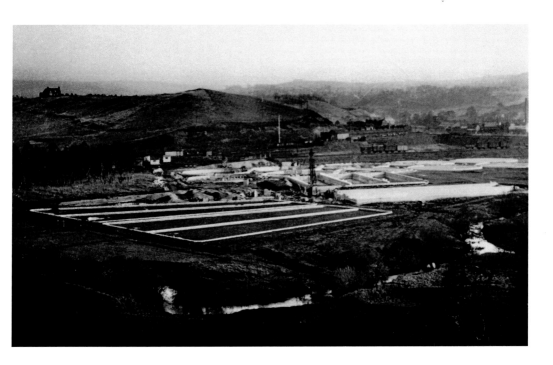

Leek Sewage Works

In 1934, the sewage works at Leekbrook opened. Previously, there had been a sewage works at Barnfields; before that the sewage from Leek's north and south drainage districts was discharged from the sewers into either Birchall Meadows, or at the bottom of Mill Street. At these points the sewage was spread over large areas of land and subjected to 'broad irrigation', eventually washing into the River Churnet. The Churnet eventually became so polluted by this and dyeworks' effluent that the large Leekbrook works became necessary.

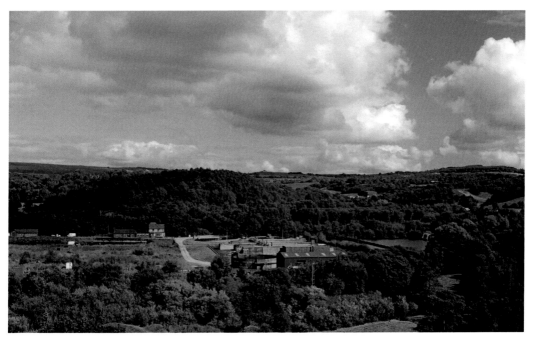

Cheddleton

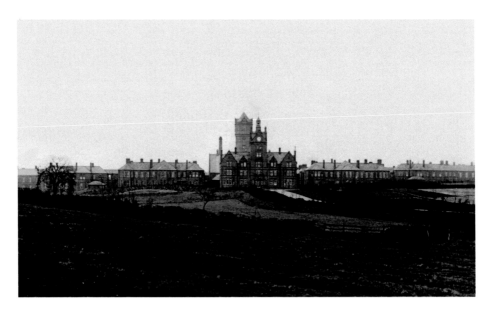

St Edward's Hospital (The Asylum)

St Edward's Hospital was built on the 175-acre Bank Farm site between 1895 and 1899 when it opened. Originally built to house 600 patients – 300 men and 300 women – it had the capacity for 200 more. The hospital was largely self-sufficient with a farm, shoemakers, and bakery. When it closed in 2001, many buildings including the central block and the impressive water tower were converted into dwellings. There is now a large population on the site, yet the nearest shop is 1½ miles away.

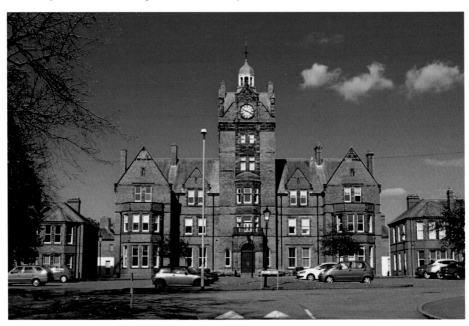

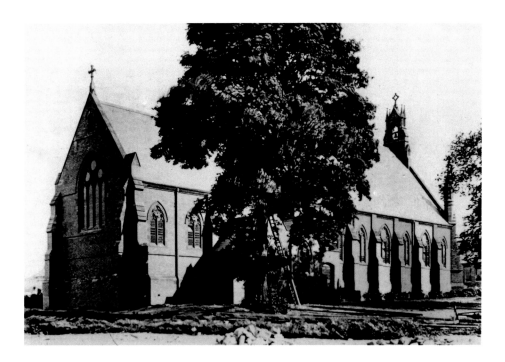

St Edward's Hospital Chapel

The hospital chapel was considered an essential facility to ensure that patients could maintain their religious devotions. It was built to seat 500 patients and staff, but men and women were strictly segregated and had separate entrances on opposite sides of the building. The medical superintendent had his own pew, and there were also special rooms patients could be taken to in case of seizures or disruptive behaviour. The chapel still stands today, and plans exist to convert it into a private house.

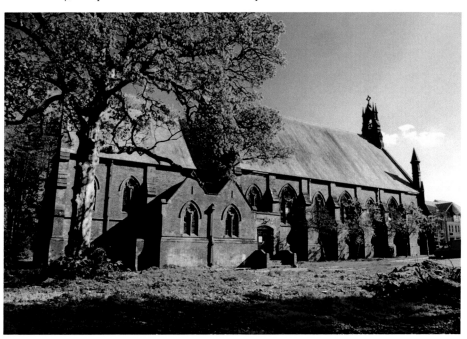

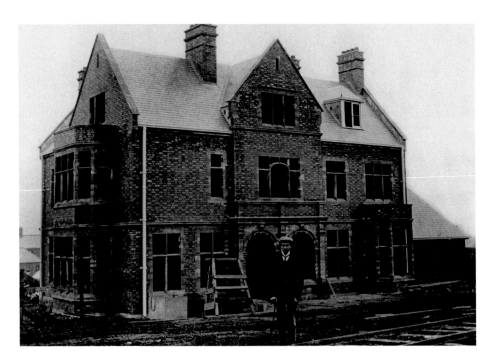

St Edward's Hospital, Medical Superintendent's House, During Construction
This Grade II Listed house was built to house the medical superintendent of the County Lunatic Asylum, as St Edward's was originally called. The house was built, as was most of the hospital, from Wall Grange bricks with red sandstone detailing. The first occupier of both the position, and the house, was Dr W. F. Menzies. Today, the building is divided into apartments and goes by the name of Malloy House. It is unclear why the house was eventually named for Dr 'Jock' Malloy rather than for Dr Menzies.

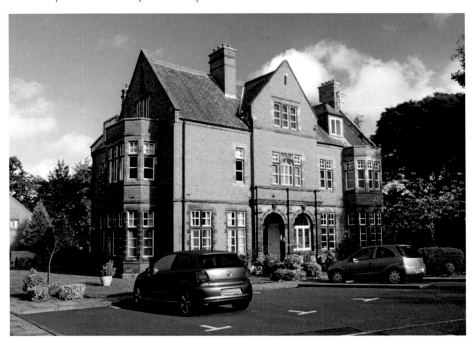

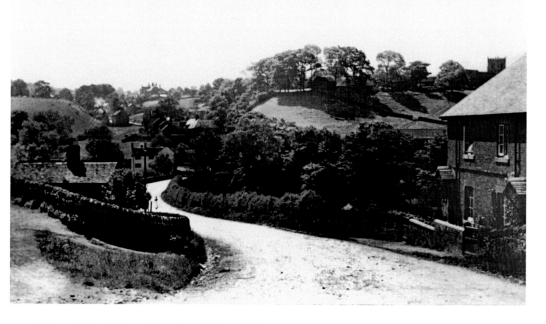

View of Cheddleton from 'Hospital Bank'

This slightly faded postcard image shows a number of changes that have occurred at the Leek end of the village. The two houses on the right remain unchanged, but the small building on the left and the large white building in the Tanyard have both gone. In the distance on the hill beyond the village, is the old vicarage (Langdale House) with its stable block at the rear. Today, this scene is dominated by mature trees and Langdale House is no longer visible.

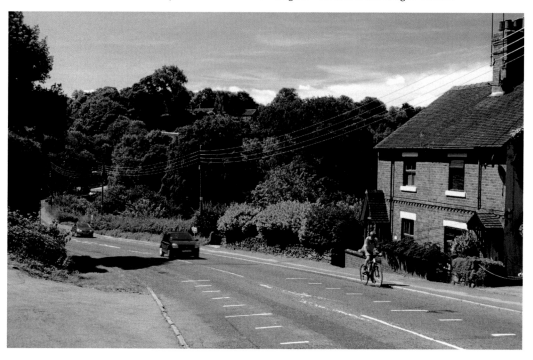

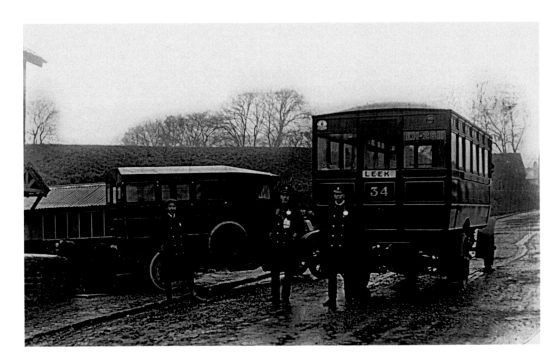

Bus Stuck on 'Hospital Bank'

This bus has become stuck on ice halfway up 'Hospital Bank' en route to Leek. Although the fields are not white, there is slush visible under the smaller vehicle. The crew were probably not enjoying their predicament at all, and are swaddled up against the cold. They have placed chocks of stone behind the bus wheels to prevent it sliding back down the hill. Today, much larger vehicles negotiate this hill successfully in all but the most trying of conditions.

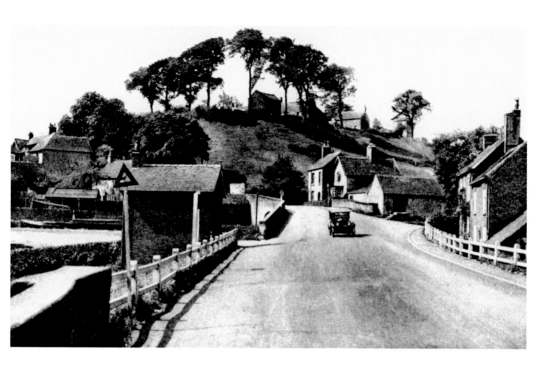

Approaching Cheddleton from Leek

Apart from the growth of a lot of trees, little has really changed in this view today, except for the demolition of the tiny butcher's shop in the left foreground (*see next page*). Another noticeable difference is the absence of traffic; this road is a major route out of Leek and is busy at all times of the day. To see only one vehicle in this scene would be surprising. The lorry shown in the new photograph is entering Bateman's factory.

Samuel Clowes' Butcher's, Cheddleton
This small butcher's business stood next to the access to Bold's shop (now Castros), and can be seen on the previous postcard image. Here (*c.* 1920s) Jack Wheeldon stands outside, although the sign on the left-hand wall proclaims the establishment to be 'Samuel Clowes Family Butcher'. In the window, the word Cheddleton can be clearly read on a notice. Beneath the name, the sign proclaims 'English Meat only'. No New Zealand lamb or Argentine beef for Cheddletonians then it seems.

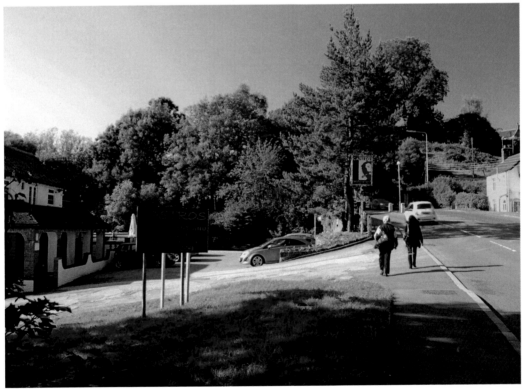

Bold's Shop, No. 11 Cheadle Road
This building was formerly The Bridge Inn, but was converted into a shop by John Bold between 1871 and 1881. The family remained as shopkeepers there until 1 November 1965. After the Bolds left, it stood empty for a considerable length of time before becoming first The Flintlock and now Castro's Mexican restaurant. It also now houses the administration department of L. M. Bateman's who own the building. Bateman's manufacture all types of agricultural metalwork, including gates and cattle crushes, in a large part of what was Brittain's paper mill.

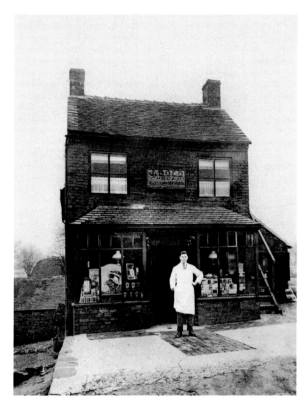

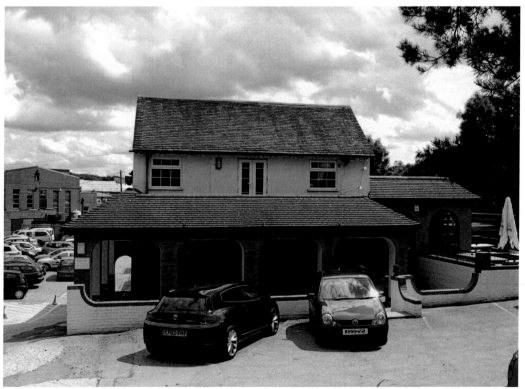

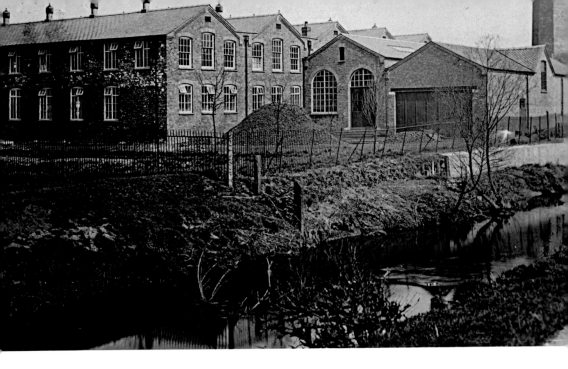

Brittain's Paper Mill

An entire book has already been written about the history of Brittain's paper mill, which seems to have been established around 1797. Many photographs of the works exist from between the dawn of photography and the company's winding up in 1980. There have been changes throughout the history of the site, and it is difficult to recreate some of the old images today. Instead, two views of the entire site from the high ground at Cheddleton Grange have been used to show how it now looks.

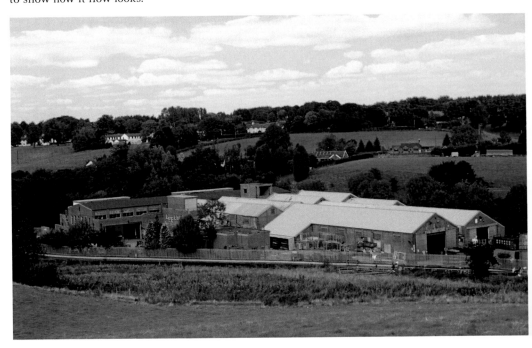

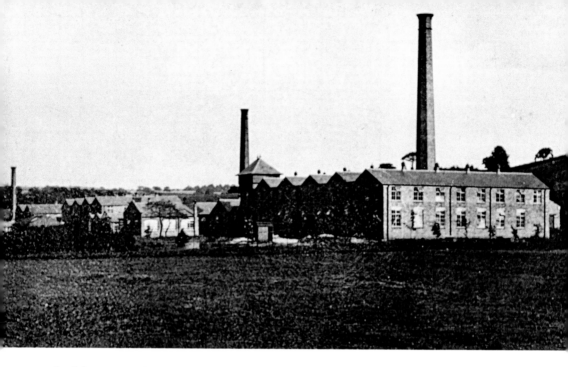

Brittain's Paper Mill

Cheddleton paper mill had already been in existence for nearly a century before it came under the control of the Brittains and their relations by marriage, the Haighs. Thomas Brittain came to run Ivy House paper mill in Hanley following its former owner's bankruptcy, but was unable to expand sufficiently to cope with the increasing demand for tissue used for applying transfer decoration to pottery. In 1890, the Cheddleton mill was leased by Brittain, Frederick Haigh and their partner, Joseph Clay.

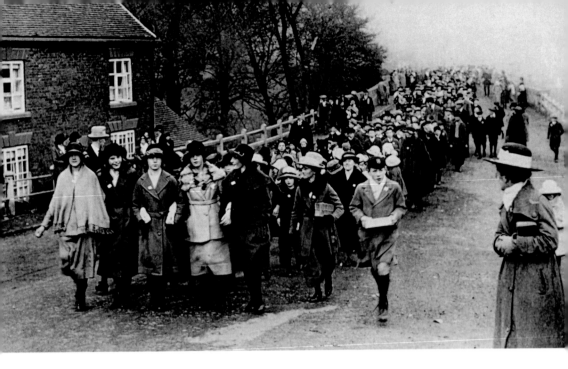

'Beating the Bounds'

'Beating the bounds' stretches back to before the Norman Conquest, when maps were almost non-existent. It involves the church leader of a parish leading a walk around the boundaries to teach children exactly where these boundaries lay, and to make it clear where they were allowed to roam, hunt or gather firewood. On the front row of the old photograph are sisters Edna May and Ida Nellie Kent from the brewery, and Mary Burndred. The new photograph shows the Buxton Billerettes following the same route in the 2014 carnival.

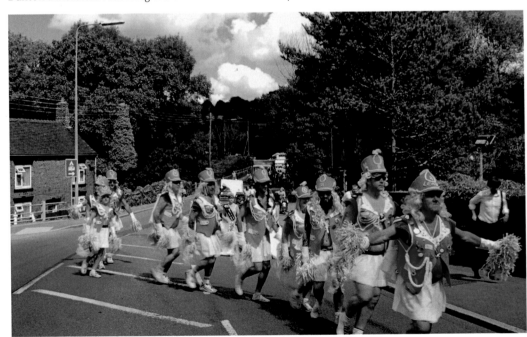

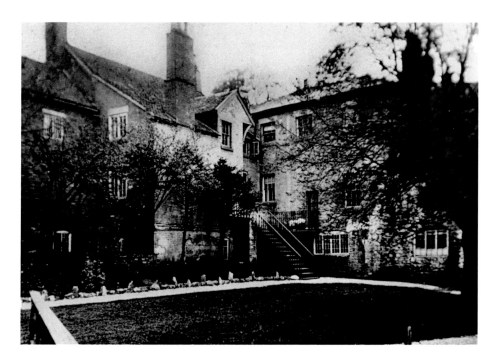

Brewery House, the Garden

The Brewery House was occupied in the 1870s and '80s by John Illsley, master brewer, and his family. Previously, Illsley had been valet to Joseph Neeld of Grittleton House, Wiltshire, a solicitor who had inherited £900,000 from his silversmith father in the 1820s – an almost unimaginable fortune. In 1901, the proprietor of the brewery was William Burton and, in 1911, it was Reuben Kent. Ten years earlier, Kent had been a brewer's labourer, living at Daisy Bank and possibly working for Burton.

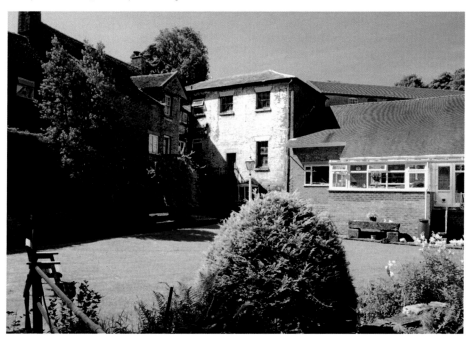

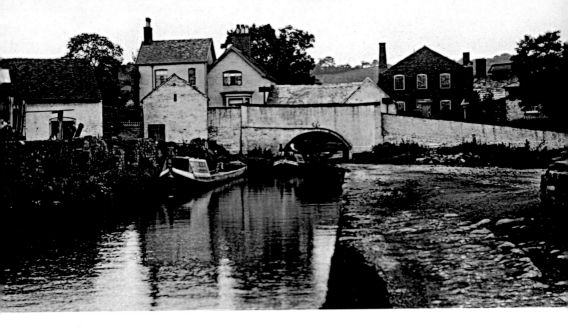

Cheddleton Wharf

The Caldon Canal, or rather the Caldon branch of the Trent & Mersey Canal, was created in 1779 and runs 18 miles from Etruria – via Cheddleton – to Froghall. The initial purpose of this branch was to transport limestone extracted from quarries at Cauldon Low to wherever it was wanted. It also provided the means to transport raw flint to Cheddleton Mill, and ground flint out to the Stoke-on-Trent potteries. It also facilitated the transport of bricks from Wall Grange Brickworks to Leek, Stoke-on-Trent and St Edward's hospital.

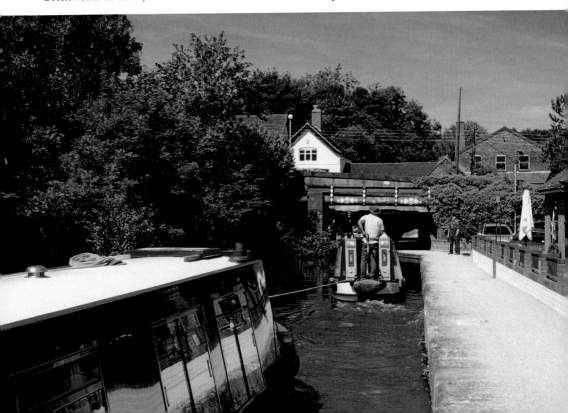

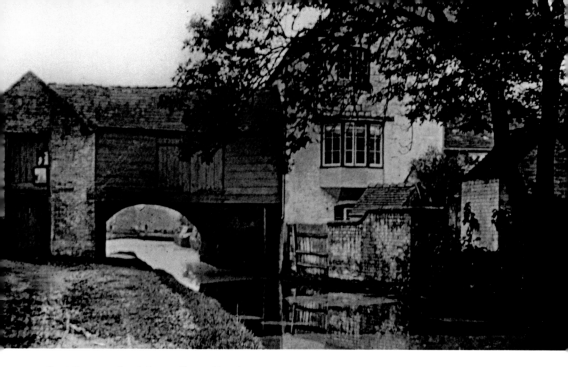

Cheddleton Wharf from Flint Mill Side

Cheddleton Wharf sits on both sides of the bridge carrying Cheadle Road through Cheddleton. On the north-west side of the bridge it provided mooring for the old silk mill, now Churnet Hall, and the pair of mills on the River Churnet. The canal runs parallel to the River Churnet for a considerable distance, and at Oak Meadow Ford, it locks down into the river and the two continue as one as far as Consall, where they separate again. The Bridge Inn used to be located where Castro's restaurant is today.

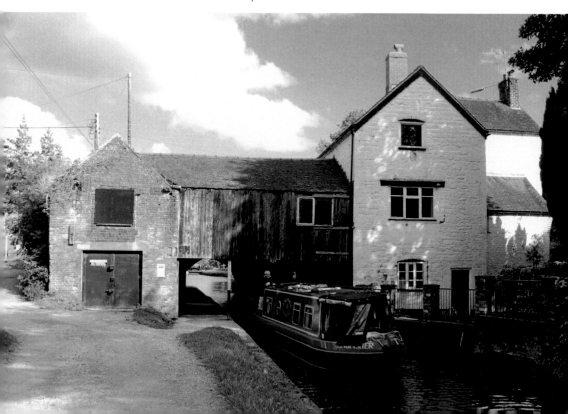

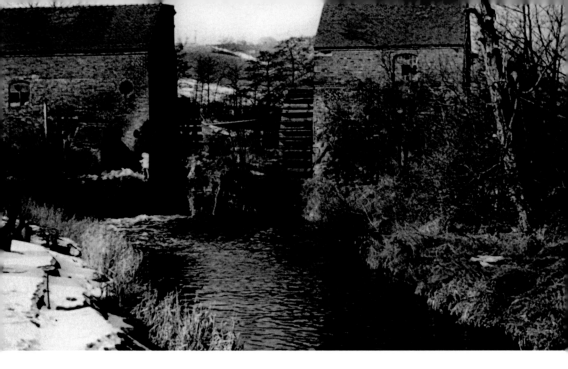

Cheddleton Flint Mill (with Snow), February 1963
What is now called Cheddleton Flint Mill actually consists of two separate mills: a corn mill, possibly dating back some 800 years, and an eighteenth-century flint mill used to provide ground flint for use in the pottery industry. The two mills are powered by the River Churnet and also stand adjacent to the Caldon Canal, which was used to bring in raw material and carry out the finished products. Both large undershot waterwheels are maintained in fully operational condition by the Cheddleton Flint Mill Industrial Heritage Trust.

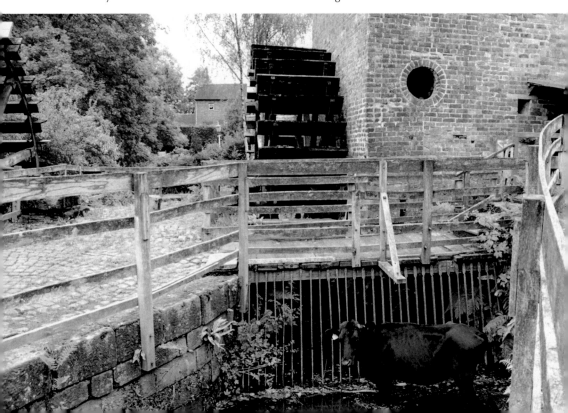

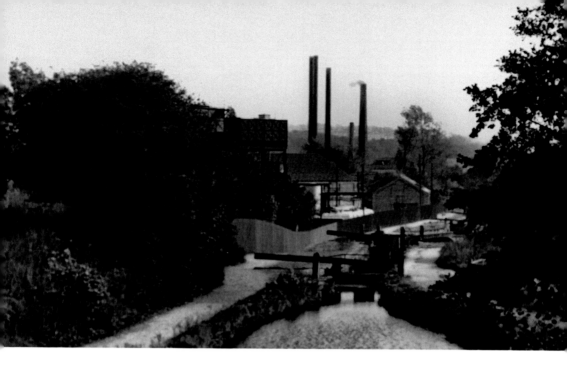

Canal Locks and Brittain's Paper Mill, *c. 1960*

This pair of photographs of the Brittain's paper mill site are clearly of the same view, as the two buildings beyond the trees are recognisable in both. What is dramatically different though, is that the large paper mill water tank and chimneys have now been removed. Security is taken more seriously today, with metal fencing all the way along the towpath, but at least an attractive screen of trees has been planted, which looks at its best in the recent photograph.

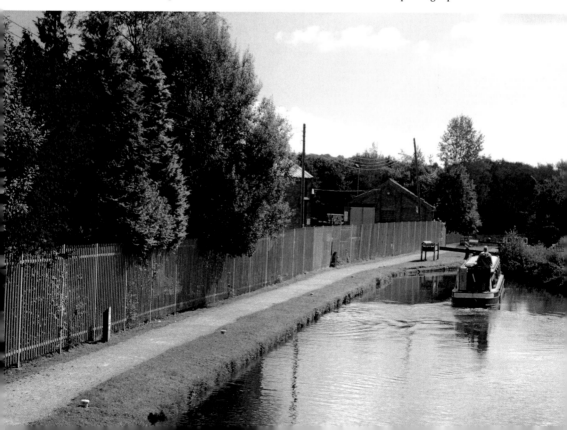

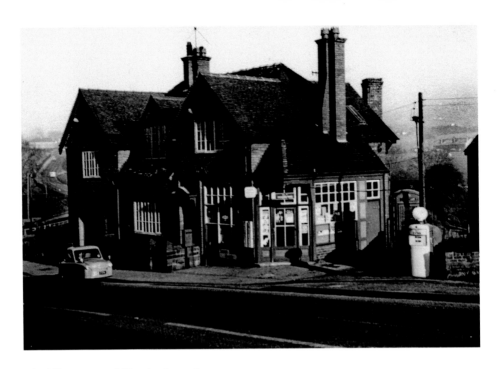

Cheddleton Post Office in the 1960s

There have been many old photographs taken and published of Cheddleton post office, and it has possibly been operating from the same building since it was built around 1900. In 1911, the sub-postmaster was Mr Benjamin Bird Wills, who was also a grocer and baker from Warwickshire. The 1960s photograph, shows that apart from the usual post office services, Cheddleton post office had also ventured into selling Esso 'extra' petrol. It remains open in the same building today.

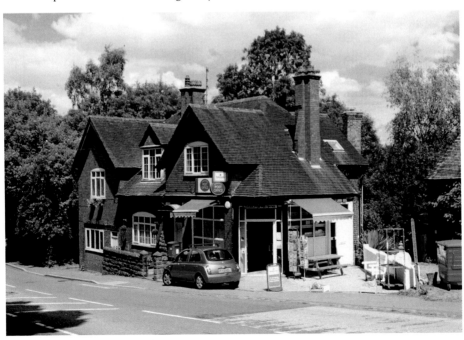

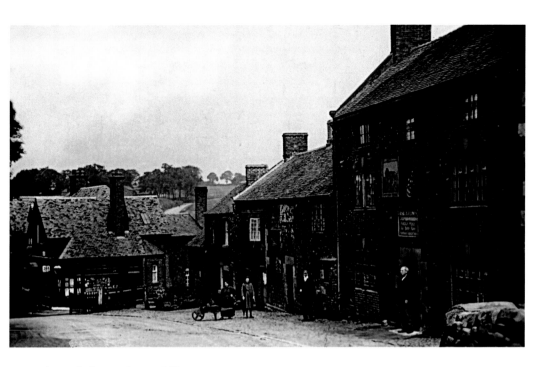

The Red Lion and Post Office

The Red Lion is the only Cheddleton pub standing on Cheadle Road, the main road through the village. A Red Lion has been in existence in Cheddleton for two centuries or more, and may have always been in this building. At the time of the old photograph, Joshua Clowes was landlord, although he could not have been there for very long because in 1891, he was keeping the Roebuck in Hanley and, in 1901, a pub in Legge Street, Stoke-on-Trent (now in Newcastle).

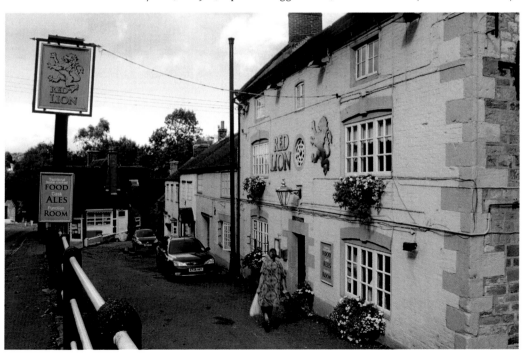

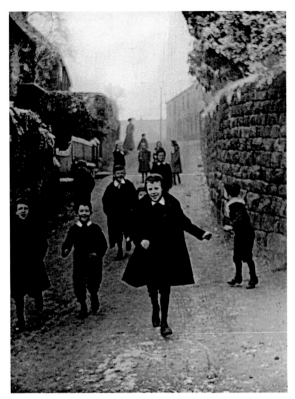

Winter Laughter in Hollow Lane

This atmospheric old photograph captures a group of children making their way home from school on a winter's day. Balaclavas, hand-me-down overcoats and hands thrust deep into pockets were the order of the day. Today, Hollow Lane looks almost exactly the same, the main difference being the care that both parents and children need to take to avoid the high volume of traffic travelling in both directions at school drop-off and collection times, along a road entirely devoid of pavements.

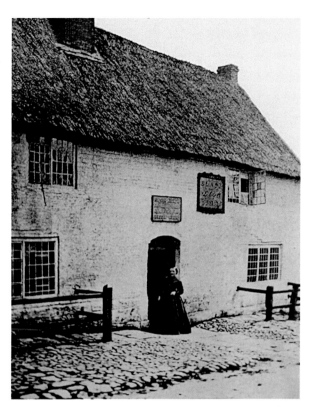

The Black Lion Inn, *c.* **1875**
This image is undoubtedly one of the oldest in the book, and shows the Black Lion Inn when it still had a thatched roof. The wooden structures outside the pub are hitching rails, just like those from old Western films, showing that people must have called at the pub when travelling between towns and villages on horseback. The landlord at the time was James Walker, who is known to have been 'mine host' between the 1840s and 1886. The lady shown may be his daughter, Mary Ellen.

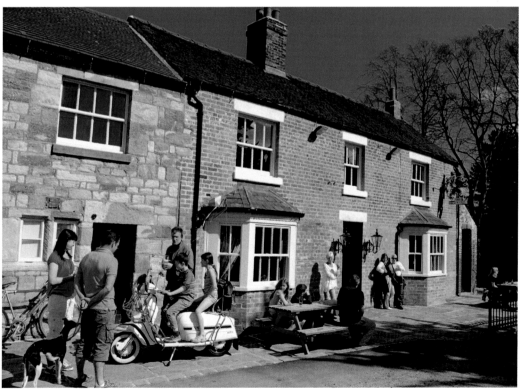

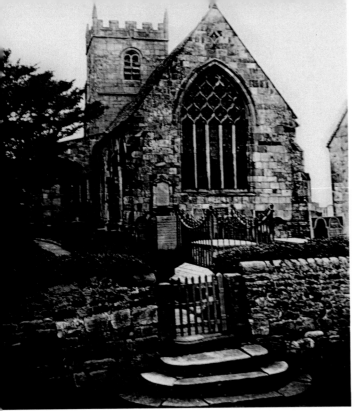

**St Edward's Church
with Dame School**
This photograph was taken
from outside the Black Lion,
probably early in the twentieth
century. The main difference
between then and now is the
building just visible on the
right, which is believed to
have been the first Cheddleton
school, endowed by James
Whitehall. Once the national
school opened in 1855, the
Whitehall school closed, and
later the decision was taken
to demolish it. Once taken
down, the materials were
used to build the choir house,
used today for choir practice
and church functions such as
coffee mornings.

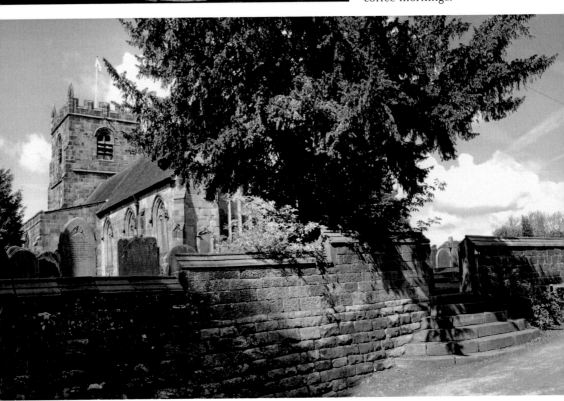

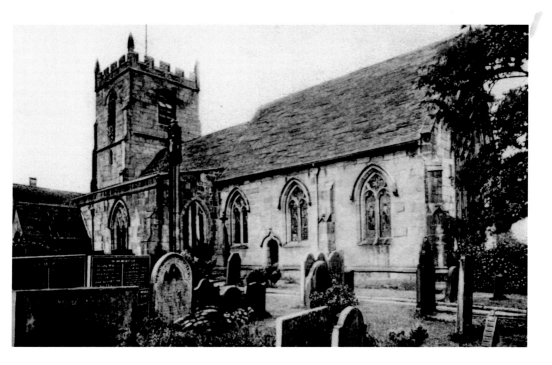

St Edward's Church

Like most churches, the parish church of St Edward the Confessor in Cheddleton has been subjected to numerous alterations/modernisations. Parts of the church date from the thirteenth century, although there may be fragments of walling dating from an earlier (twelfth-century) church. Major alterations took place in the Elizabethan period, and the final major structural changes were carried out in the 1860s by that great despoiler of early English churches, George Gilbert Scott Jnr. A large proportion of the stained glass is by William Morris & Co.

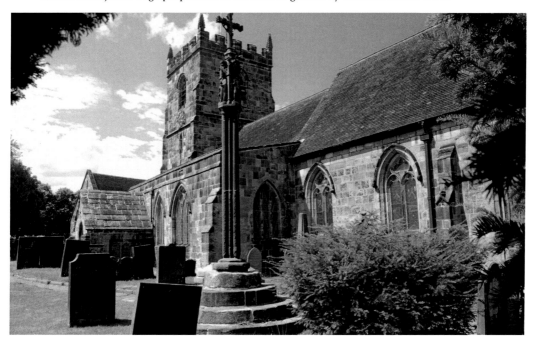

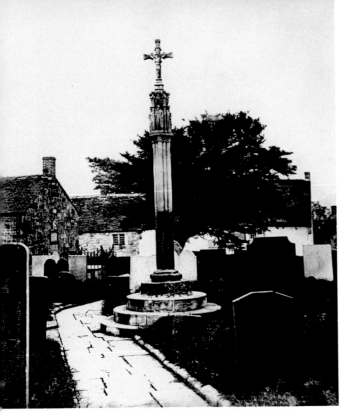

Black Lion Inn, Churchyard Cross and Whitehall School

This photograph shows part of St Edward's churchyard and the Whitehall school. There was a plaque and a sundial on the end wall of the school. The end of the Black Lion can be seen on the far right, which at this time was still thatched (*see page 27*). The cross in the churchyard has a medieval base, but the top section was added by George Gilbert Scott Jnr to a design by William Morris, depicting the instruments of the passion.

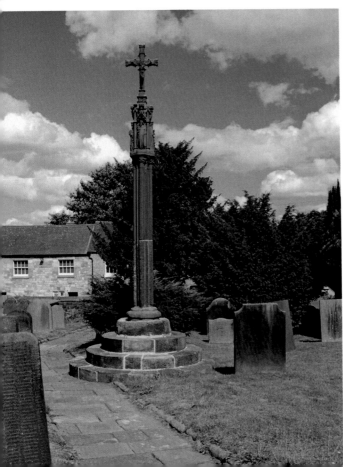

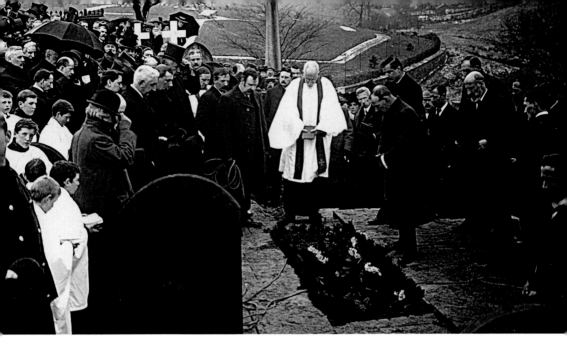

Ronald Rider's Burial, 30 January 1908

Ronald Rider was the son of William Henry Rider, silk manufacturer, who had moved his family from Leek to Basford Hurst in the 1890s (*see pages 81 and 82*). It was not to be a happy home, because Ronald died aged just twenty-seven in January 1908, and William Henry, in December 1909. When Ronald's mother, Martha, died in 1932, Basford Hurst was sold to one of the Walker brothers of Century Oils. The modern photograph shows the Rider family memorials today.

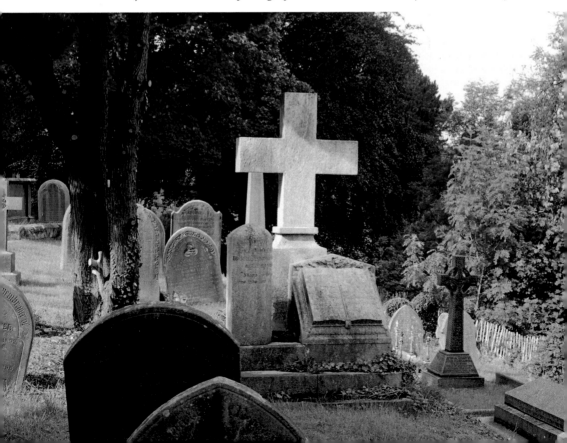

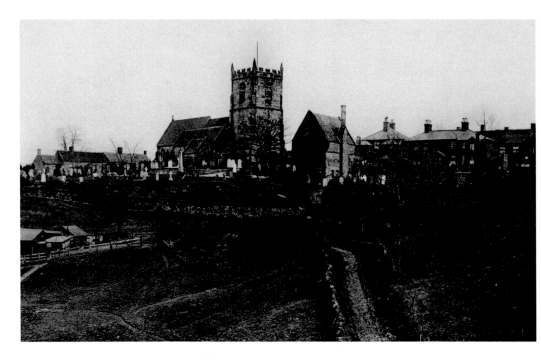

St Edward's Church from the Rear

This scene is dramatically different today, shown by the photographs. A footpath leads from Park Lane, joins a farm track and then climbs up to the churchyard via a set of steps. Here it passes the Morris gravestone, although it is not immediately obvious whether this stands on consecrated ground, or whether it was excluded for some reason. Today, the track and the footpath still survive, but they are not easy to walk, and the view of the church is completely blocked by trees.

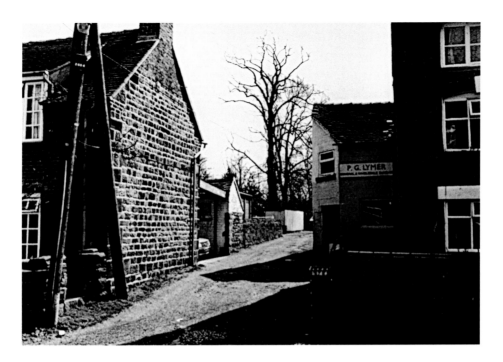

P. G. Lymer's Butcher's, No. 25 Hollow Lane

P. G. (Philip) Lymer was the third generation in a Cheddleton butchery business, reaching back into the eighteenth century. The family reared animals on land behind the shop and also kept a slaughterhouse. Both the shop and the slaughterhouse closed on the last day of the millennium, owing to family illness. The family also ran a butcher's in Moorhouse Street Leek. Today, Lymers still own the land, Crown Point Farm, and run a butcher's in Ball Haye Street under the name of J. W. Ash.

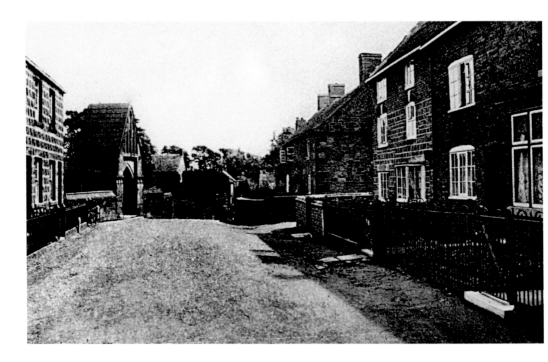

Hollow Lane

Another pair of Cheddleton village photographs in which virtually nothing has changed. The only differences revolve around vegetation, with the yews in St Edward's churchyard no longer kept cut short, and the magnolia in the garden on the right, just beginning its second flowering of the year when the recent photograph was taken. The flowers on the left look bright and beautiful, and altogether the picture is one of an attractive traditional village centred on its ancient parish church.

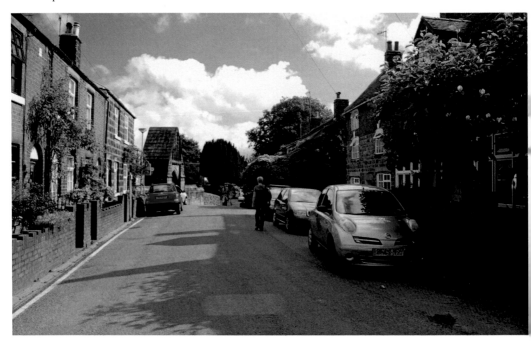

The Old Village Shop, No. 26 Hollow Lane

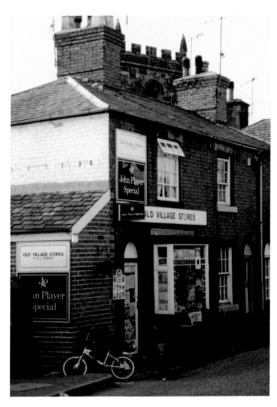

The village shop was open as a shop for at least sixty-four years, before its closure in 1985. The earliest known proprietors were the Bestwicks in 1921, followed by the Traffords, White and Needham, Turners, Medleys, Traffords (again) and finally, the Oldfields. Like many village shops, it relied on the local economy; a large proportion of the shop's custom coming from schoolchildren and their parents. When the schools were reorganised and junior-age pupils went to school in Leek, the shop became unprofitable and was closed.

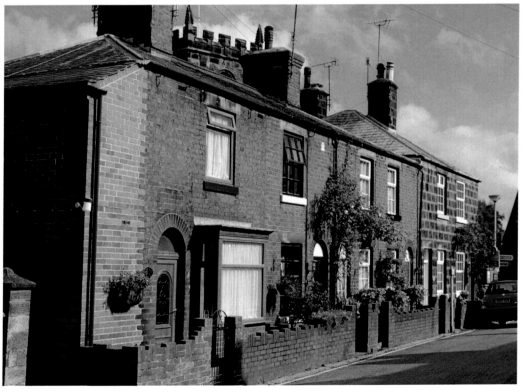

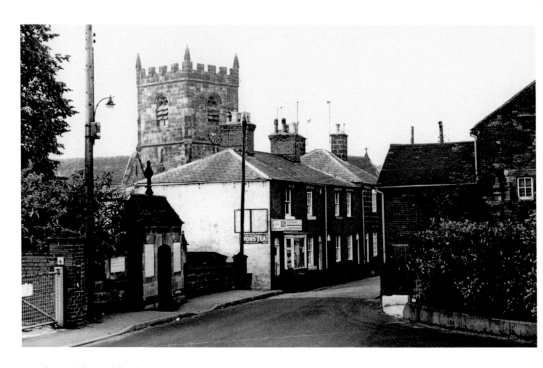

London Bridge with Shop, *c.* 1970

The part of Cheddleton village where Ostlers Lane joins Hollow Lane has long been known as London Bridge but no one seems to know exactly when or why it acquired that name. The shop at the end of the terrace (*see previous photographs*) was run at the time by the Trafford family. This must have been the second time it was run by people of that name because the shop is advertising Players No. 6 cigarettes, which were not introduced until the 1960s.

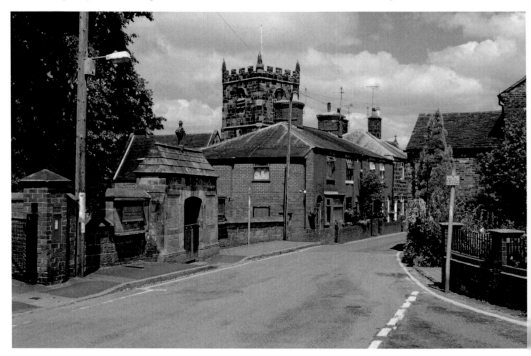

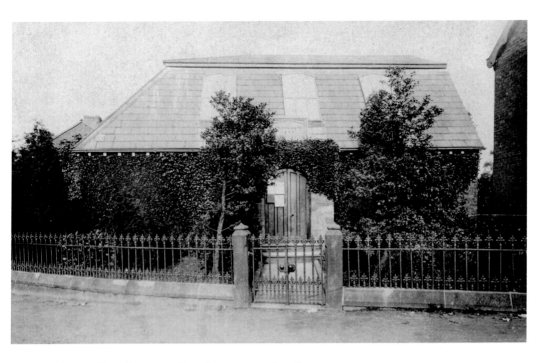

Wesleyan Chapel Corner of Ostlers Lane and Hollow Lane

The Wesleyan chapel, now a private house, was built in 1849, as stated above the door. Perhaps surprisingly, its pews could seat as many as 160 people. Also unusual was the fact that the chapel was devoid of wall windows, instead, being lit by seven large roof lights. Although reduced in size, some of these lights are still in existence, now only serving the first floor. The ground floor front wall has had large windows inserted into it and, overall, the house must be filled with light.

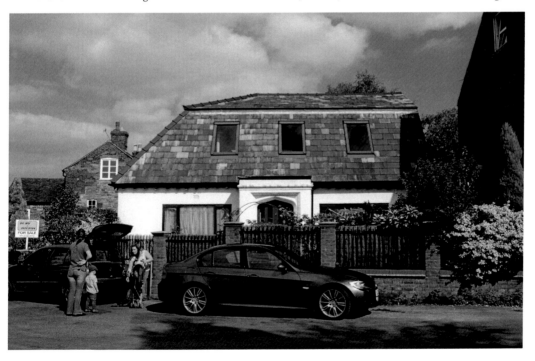

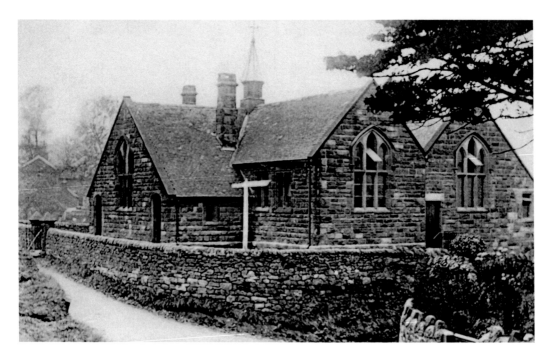

The Old School

In 1855, the National School opened, resulting in the immediate closure of the school near the end of the church. Over time, the number of children in Cheddleton increased until the National School was unable to cope. Thus, in 1906, a new school, now Cheddleton Community Centre, was opened. Later still, even more capacity was needed, and so the Church of England Junior School was built across the road. Juniors now travel to Leek, and the old National School has been converted into tea rooms.

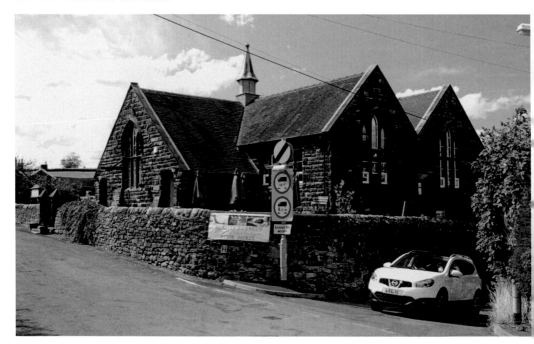

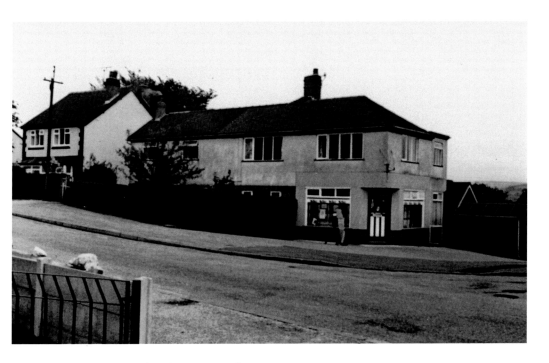

The Shop, Corner of Ostlers Lane and Ox-Pasture

'The shop' was in operation from at least the early 1950s, until its closure in the 1990s. It was apparently operated by Johnny Bold and his wife, Gertie, in the 1950s. The Bolds sold it to Harry Pettit, a butcher at St Edward's Hospital, and it then seems to have passed through several hands, all of whom seem to conjure up pleasant memories. Geoff and Bessie Whitehurst kept it, then Peggy Cunningham, and finally Sue Greenfield, who closed the shop in the 1990s and converted it into a house.

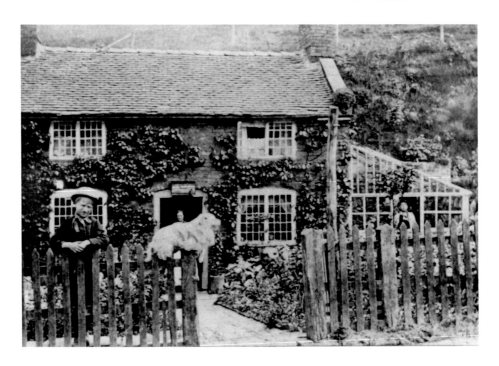

Babylon

This is the end of a row of cottages known as Babylon, although no one today appears to know why. Certainly the name Babylon was applied to the cottages in the 1891 census, and may have been in common usage long before that. The ground floor of the cottages were eventually converted into lock-up garages, which survived into the twenty-first century. They were then demolished and replaced by the two pairs of semi-detached houses shown here. The Babylon name was perpetuated by calling this mini development 'Babylon Bank'.

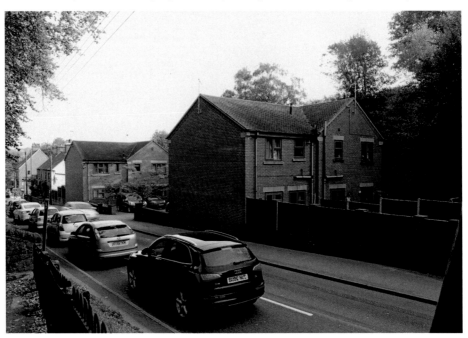

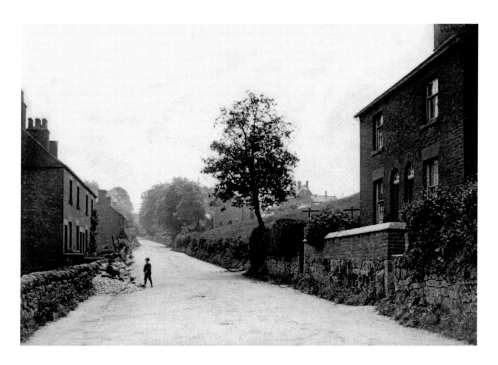

View up Cheadle Road Towards The Fox Inn

This tranquil scene is Cheadle Road, taken more than a century ago. The date is approximately 1900, because on the left is clearly the pub sign hanging outside The Fox, which was only open for a few years around that time. On the right is the rear of the old St Edward's vicarage, which at the time would have been only a few years old. The building behind the vicarage is the old stable block, since demolished and replaced by a dormer bungalow.

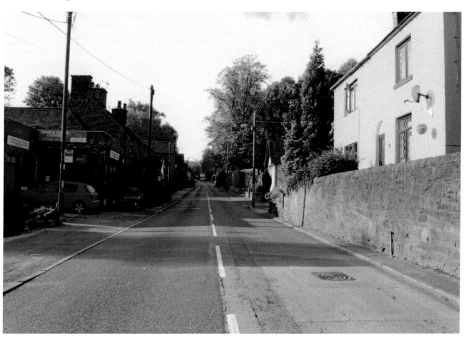

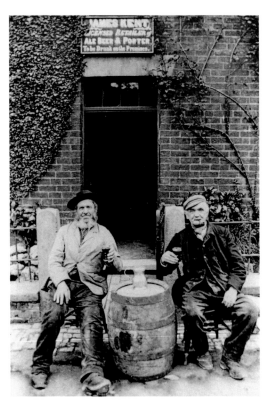

The Fox Inn

In 1901, The Fox was run by former farmer James Kent, a member of the family who already ran a brewery in the village (*see Brewery House*). James and his wife, Phoebe, lived at the Fox with their seven children. Phoebe was only thirty-three-years old at the time, and would go on to have more children. According to Robert Milner, the pub was only open for a few years and, by 1911, James had left the pub and was working as a 'brewer's traveller'.

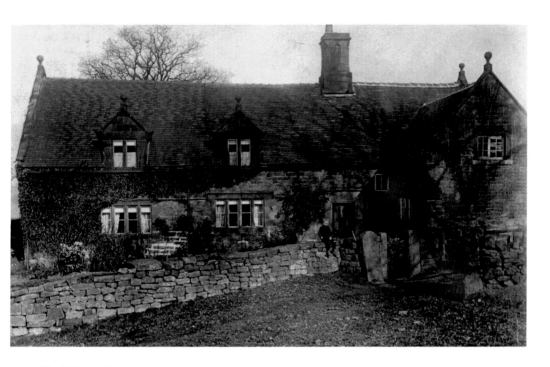

Cheddleton Grange

Externally, this is a typical seventeenth-century stone building, with finely cut stone details in the chimneys and roof windows. The stone conceals the fact that the house was originally built of timber, and that inside still stands its original 'cruck' frame. A cruck frame consists of supports at each end of the building, each pair cut from the same curved trunk and usually standing upside down. Cruck frames have been used for over 1,000 years, and this one must be at least 400 years old.

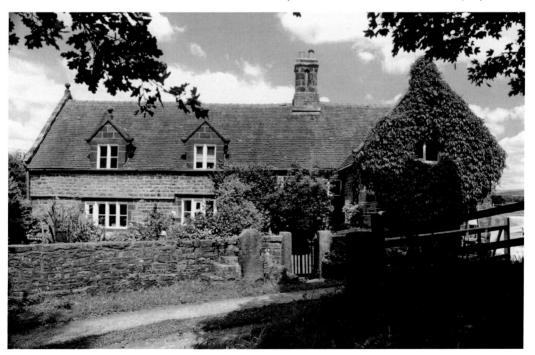

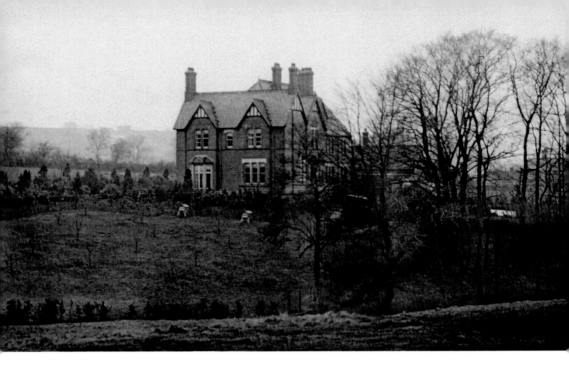

Cheddleton Old Vicarage

This now unrepeatable scene shows Cheddleton's first vicarage, built in the 1890s. Cheadle Road is hidden in the dead ground between the photographer and the house. The vicarage drive runs to the left, emerging just below today's ox pasture. The vicarage had a door and staircase for the family, and separate ones for the servants. At the rear was the stable block, and in the foreground are two beehives, a tennis court and what may be a recently planted orchard. Now surrounded by housing, the house is currently undergoing painstaking restoration.

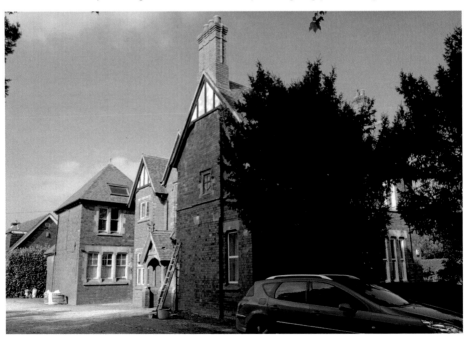

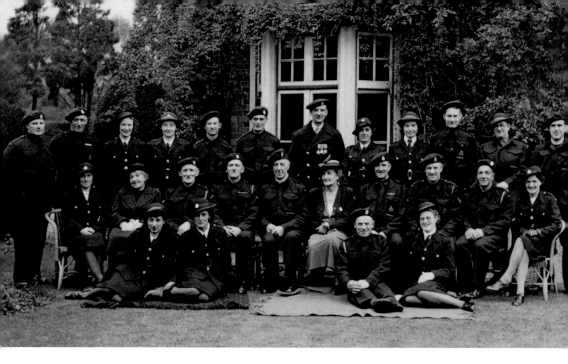

Cheddleton Civil Defence Team, Outside Cheddleton Old Vicarage

Included in this photograph outside the old vicarage are Revd William Gaisford Burgis and his wife, Marion, in the centre and a second clergyman, possibly the assistant curate of Cheddleton, on the extreme right. The photograph is not dated, but is almost certainly from the Second World War period when the Civil Defence Service was formed from the old air raid precautions, auxilliary fire service and national fire service. It was a civilian, non-combatant service, and therefore ideal for clergymen to join.

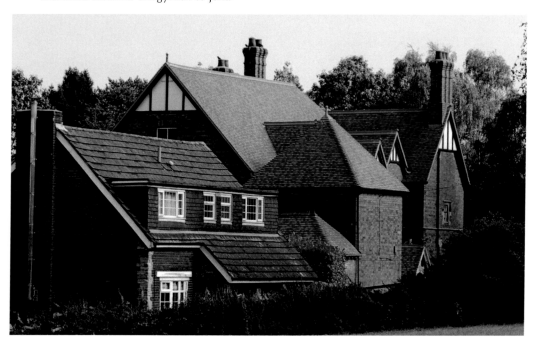

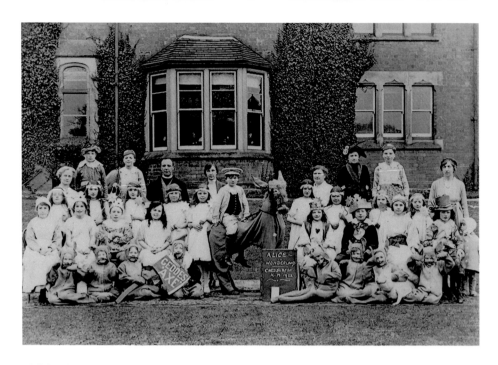

Children's Party at Old Vicarage

With its lawns and tennis court, the vicarage was ideal for staging children's parties, plays and other activities. This photograph shows the 1922 cast of *Alice in Wonderland* on the rear lawn. It is interesting that Revd Burgis has, to some extent, hijacked the group photograph for his own political purposes. The Queen of Hearts' servant has been using 'Geddes' Axe' to 'chop off their heads'. Geddes' Act was introduced by the post-Second World War Conservative government, to cut government spending, in which had increased taxes for the middle classes.

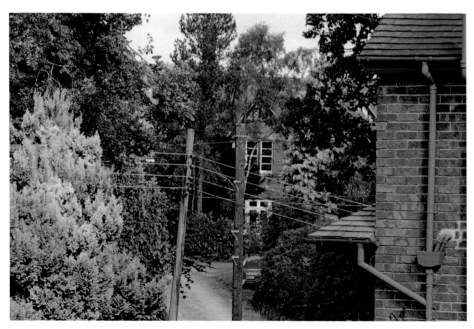

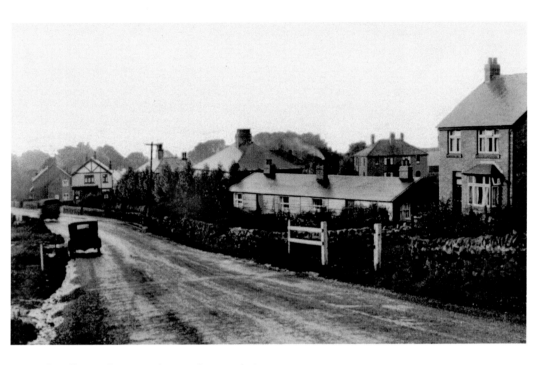

Cheadle Road, Paper Shop and Doctor's Surgery

Although a poor print, this photograph may well be unique. The house on the right was occupied by Jack and Fanny Woolridge, from its building until it was taken over as a pharmacy. It is now Millers. Unusually, the Woolridge's front room was used by Drs Elsdon and Lawson to hold their surgeries. For a long period the house has played a role in maintaining health in the village. The long, low building to the left was the paper shop, run variously by the Rutters and Mrs Bloor.

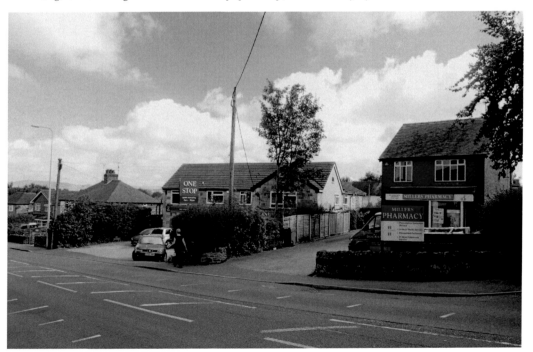

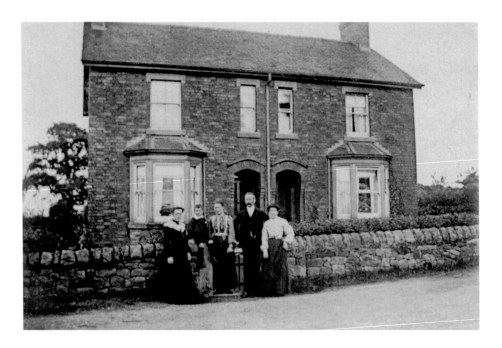

Fair View, *c.* 1900

The house formerly known as Fair View is located between Ostlers Lane and Bones Lane. Today, the house bears no name, simply the number 399 (Cheadle Road). The photograph shows Murray Milner, his wife Sarah, and young son, Eric. It also shows some of Cheddleton's healthcare professionals: district general nurse Katie Elizabeth Martin, from Pontypool and district maternity nurse Grace Harkness from Ruthwell, Dumfrieshire. The two nurses lived at Ashcombe Cottage. The houses look attractive today, with their bright white and soft apricot masonry paint.

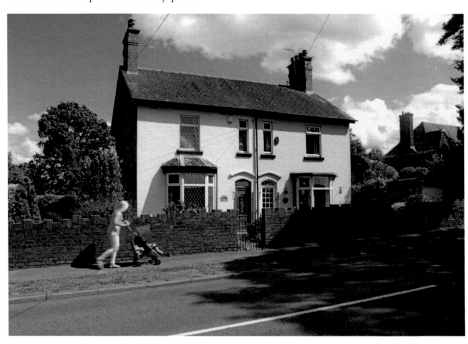

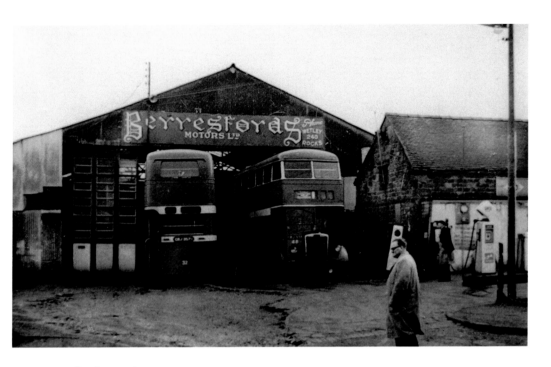

Berresford's Bus Garage

Berresford Motors Ltd set up their new base at Windy Arbour, Cheddleton, when they left their former premises at Randles Lane and Cheadle Road, Wetley Rocks in 1936. Alterations were necessary to the roof of the garage in the 1950s to accommodate double-decker buses. The cottage at Windy Arbour, formerly occupied by the Milner family, became the offices. In 1987, following the death of company head, Mr Jim Berresford, the business was sold to the PMT who took some of the vehicles and then wound up the business.

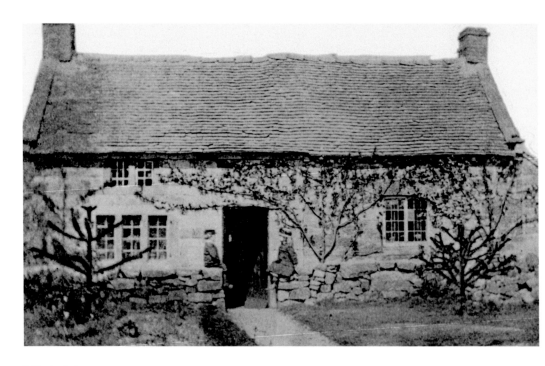

Windy Arbour

When Berresford's closed in 1987, the garage and the cottage at Windy Arbour were both in poor condition. The garage was later demolished, leaving the cottage standing alone. Prior to Berresford's, John and Mary Ann Milner had occupied it between 1870 and 1901, when it consisted of 12½ acres of land. Their children, Tom and Miriam, are shown on either side of the door. The cottage has now been beautifully restored by John Pointon & Sons, and is home to Cheddleton first responders.

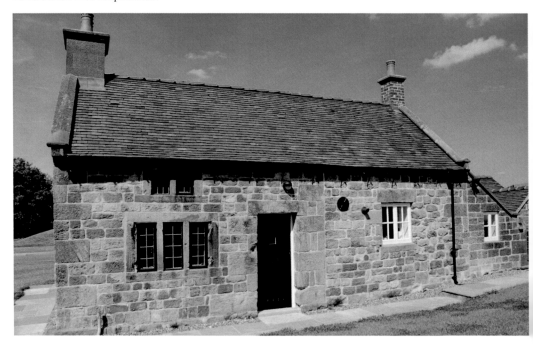

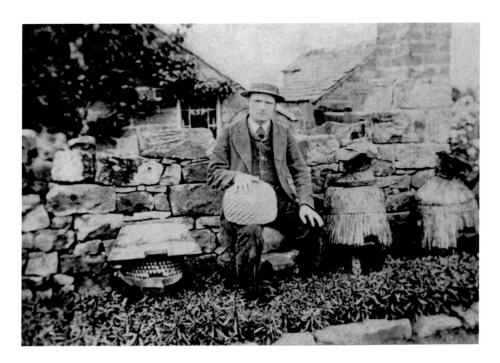

Windy Arbour Piggery, with Bee Hives

This old photograph shows Maurice Milner, a member of the family mentioned in the previous caption, sitting outside the piggery at Windy Arbour with his beehives. On his knee is a traditional bee skep, which were first woven to house bees in ancient times. Skeps would often be placed in alcoves made from wood or stone to stop them from becoming soaked by rainwater. Today, it is illegal to use skeps for hives, but beekeepers sometimes still use them to catch swarms.

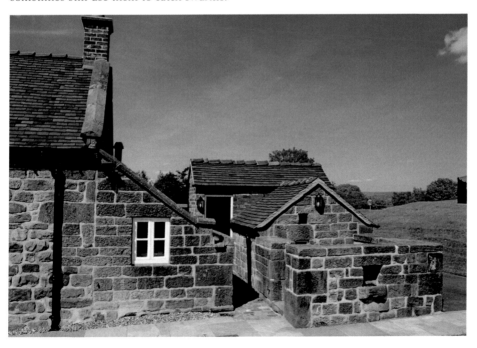

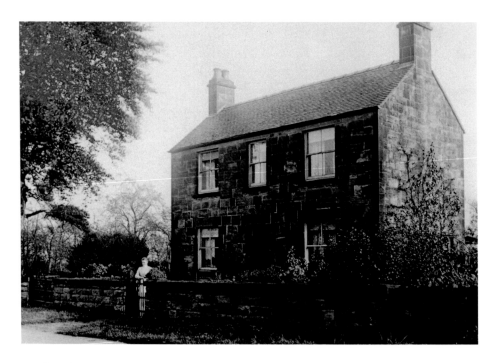

Beech Holme, 1914

Beech Holme was another of the row of houses along Cheadle Road, occupied by members of the Milner family in the early 1900s. Perhaps parcels of Windy Arbour had been given or sold to family members to build on. Thomas Milner, who lived at Beech Holme, was a stonemason/bricklayer, and Murray Milner, at Fair View, was a bricklayer and labourer, so perhaps they had built the houses themselves. The lady shown on the photograph has been named as Mabel, and so is probably Thomas Milner's wife.

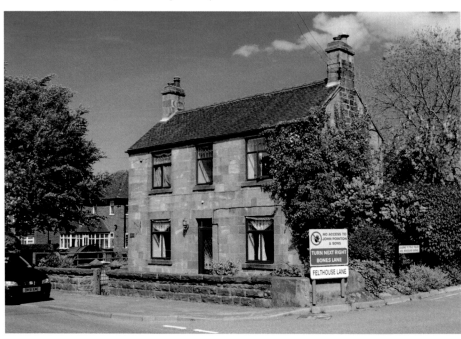

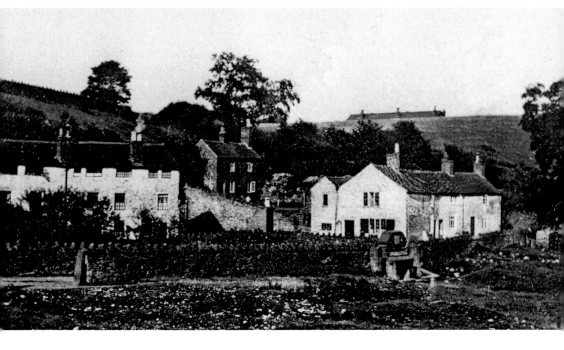

The Tanyard

The tannery, or 'skinyard' as it is often referred to, seems to have began life in the late eighteenth century. It was centred on three tall cottages, which had the large windows on their second storey, usually found in the 'silk shades' of Leek or Macclesfield. The tanyard continued in existence until the 1840s, but never seems to have commenced business again after several changes of ownership. The so-called weavers' cottages were demolished around 1980, and a single detached house now stands in their place.

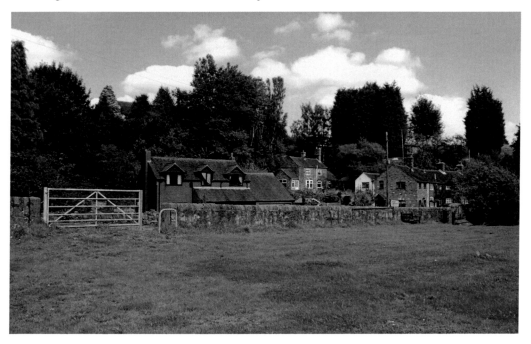

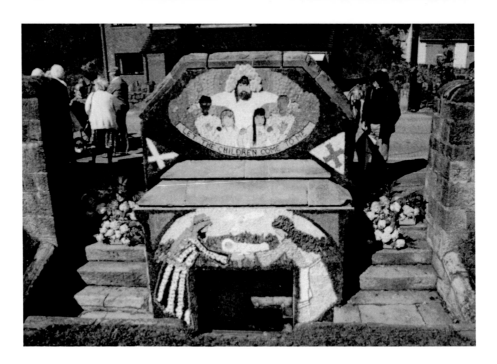

Cheddleton Well Dressing

Well-dressing is a custom in rural England, most closely associated with the Derbyshire Peak District and Staffordshire, and is believed to have originated in Tissington around 1349. It involves creating designs, usually biblical in nature, by attaching brightly coloured flowers to a framework. Well-dressing is believed to give thanks for the purity of the water issuing from the well. In Cheddleton, as elsewhere, the practice has now ceased, the last well-dressing having taken place in the 1980s. The water here has now been declared unfit for consumption.

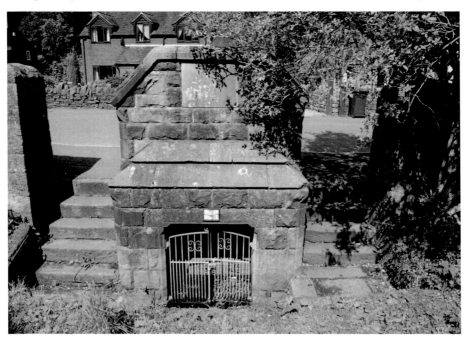

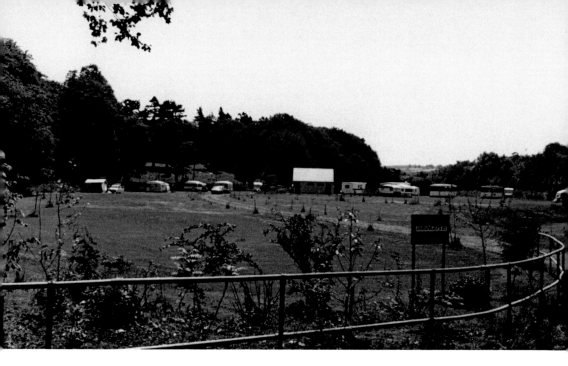

Glencote Caravan Park, Station Road

Glencote Caravan Park was opened in 1987, and covers an area of 6 acres. It accommodates a large number of static caravans and campervans, and has its own fenced coarse-fishing pool and grassed play area. It sits alongside the Churnet Valley railway line, and is only a short walk from Cheddleton station, the Caldon Canal and the Boat Inn. The two photographs show how the site has matured and how beautifully maintained it is. Numerous glowing internet reviews show what users think of the site.

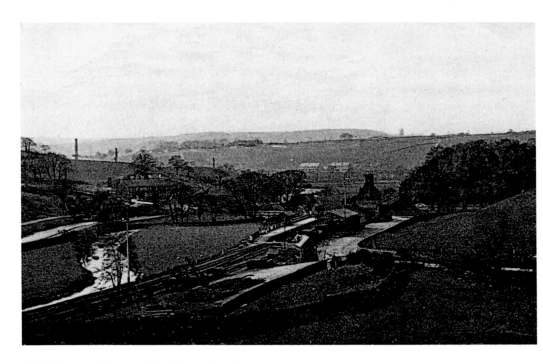

Cheddleton Railway Station (from Above)

Cheddleton station opened in 1849 as part of the North Staffordshire railway's Churnet Valley line. It closed in 1965, but Cheddleton PCC prevented its demolition in 1974, and it was Grade II Listed soon afterwards. It then became the base for a steam locomotive restoration society. As the Churnet Valley Railway, it is now a popular tourist attraction running trains to Froghall and Waterhouses. This photograph shows just how much the area has changed in the past century.

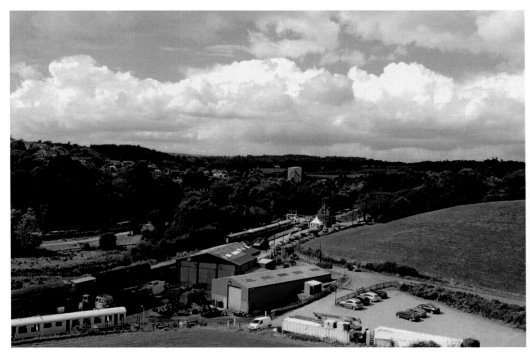

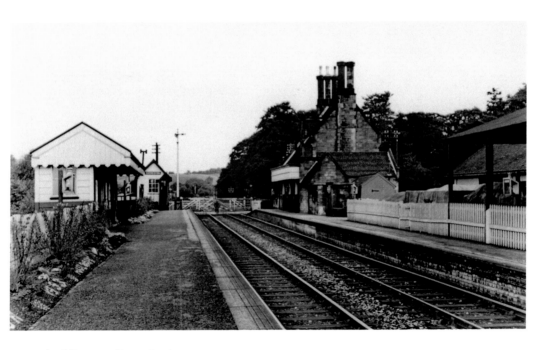

Cheddleton Railway Station, 1953

This old photograph was taken in 1953, when the station was decorated to celebrate the Coronation of Queen Elizabeth II. It is juxtaposed with a recent photograph of a Churnet Valley Railway's 1940s weekend event. These annual weekends include displays of military vehicles, people dressed as service personnel of the time, tea dances, children playing evacuees complete with gas masks in cardboard cases. Steam trains make supposed border crossings into enemy territory, where passengers may be approached by intimidating Nazi officers demanding to see their papers.

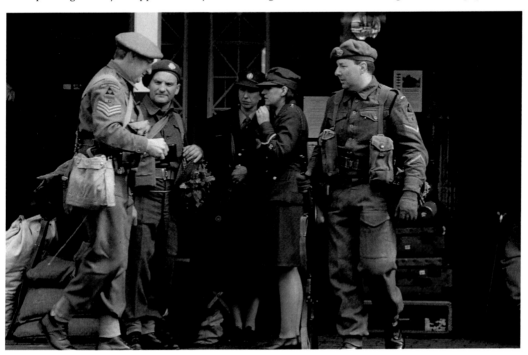

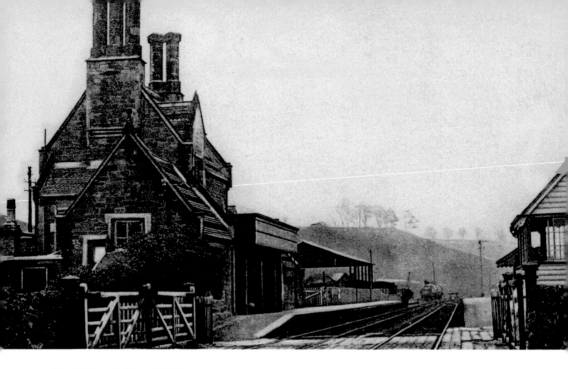

Cheddleton Railway Station
This old postcard looking towards Ipstones shows the Cheddleton station buildings more clearly. In the background is the hill from which the first photographs of the station were taken. It is perhaps worth wondering what might have happened had the Nazis won the Second World War: would there ever have been a need for a Dr Beeching, and would the station have closed in the 1960s? Would Queen Elizabeth II ever have been crowned? Would there perhaps have been German machine gun positions to defend the line from the English Resistance?

Butter Cross, Pre-1926

The Butter Cross was located on an
old road, and is believed to have been
a place where local produce was sold –
butter perhaps being just one item. In
1926, the probably medieval column
was restored, and a small stone cross
added to the top at the expense of Mr
William Challinor of Pickwood Hall.
The old photograph shows the cross
prior to this work, and the gentleman
shown may be Mr Challinor himself.
Revd Burgis, vicar of Cheddleton,
performed a service of dedication
following the restoration.

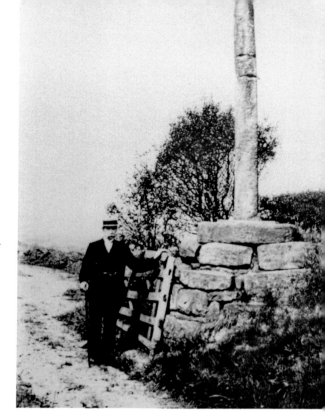

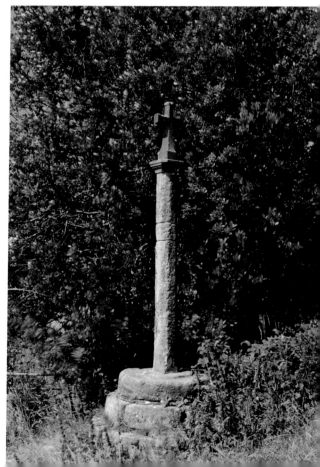

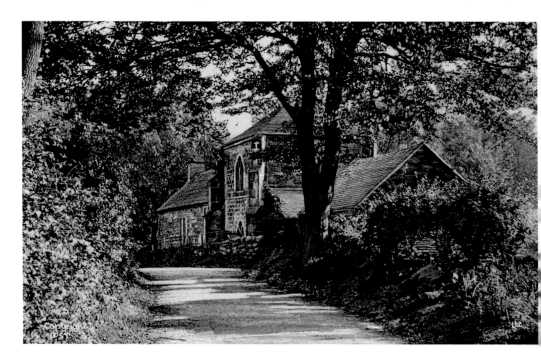

Chapel House, Belmont

This attractive miniature church sits alongside Belmont Road. It was built by John Sneyd of Belmont Hall, following a temporary disagreement with the vicar of St Leonard's church at Ipstones. Apparently, the dispute between the two men was over before the church was finished, so it was never used for services, but instead completed for use as a house. It still belonged to the Belmont estate as late as 1952, but was offered for sale as a separate auction lot.

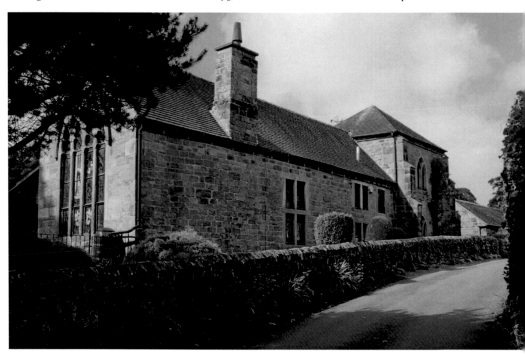

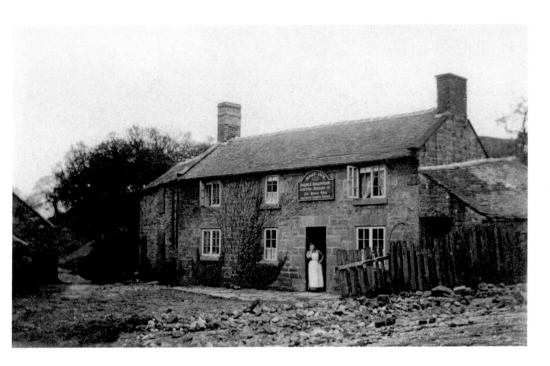

The Boat Inn

The pub now called The Boat Inn began life as 'The Navigation' – navigation being the old name for a canal. The Boat sits on the bank of the Caldon Canal, and not only does it serve good meals, but it is also the only pub in Staffordshire to boast its own ice cream parlour, serving a vast range of ice cream flavours. It slightly betters the Holly Bush at Denstone for access because it can be reached on foot, by car, by boat and even by railway.

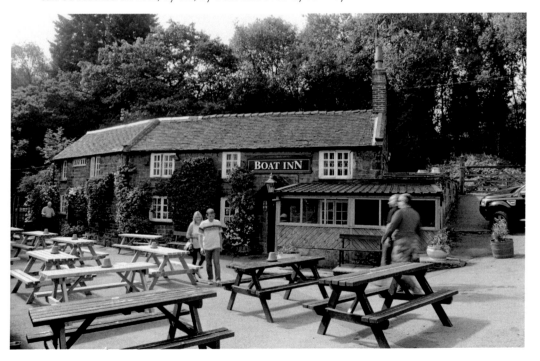

Wetley Rocks

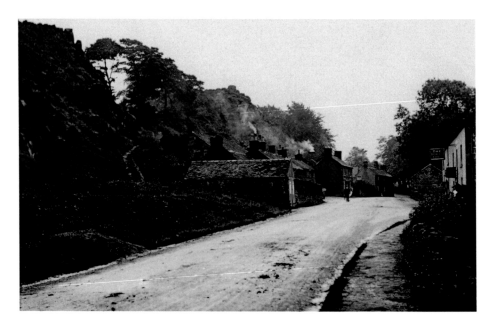

The Powys Arms

The Powys Arms was named after the Powys family who owned Westwood House, and who were for nearly ninety years, lords of the manor of Cheddleton. Prior to being the Powys Arms, the inn was the Arblasters' Arms, named after the previous owners of Westwood House. Edward Arblaster, who died in 1783, was the uncle of the Revd Edward Powys, and both the house and the lordship of the manor passed from the Arblasters to the Powys family.

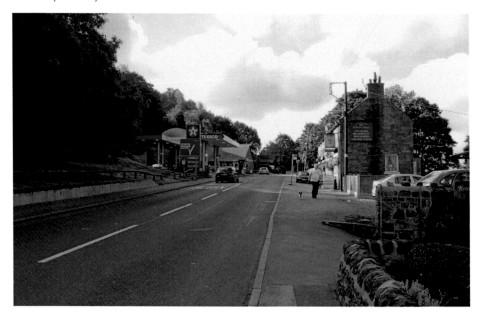

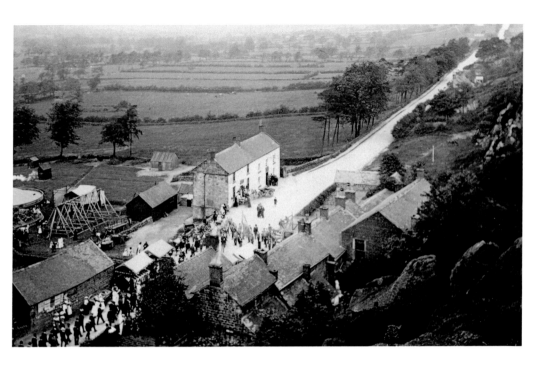

The Powys Arms from The Rocks

This old photograph was taken from, what is today, about the only bare peak of the 100-foot high cliff that gives Wetley Rocks its name. It was taken around 1910, and shows the village taking part in a large celebration. A brass band plays in the middle of the road, and a funfair and stalls have been set up. The sign for the Mason's Arms can be seen near the large flag, and a group of men are standing outside the Powys Arms.

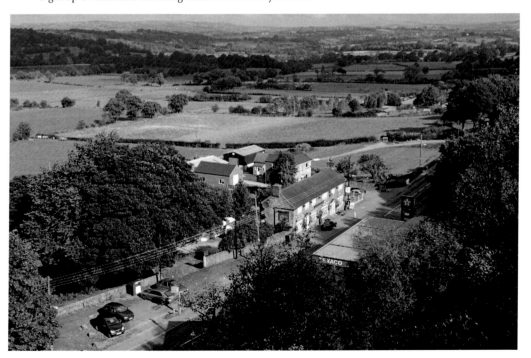

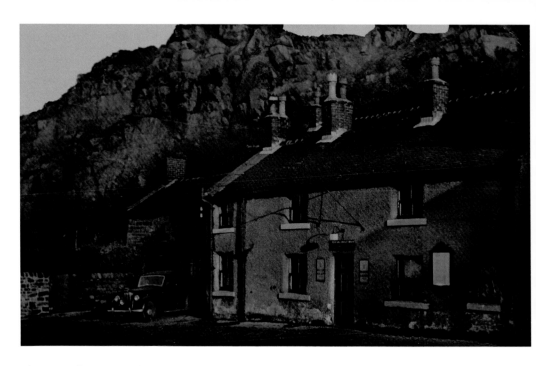

The Mason's Arms, 1960s

This 1960s photograph shows the Mason's Arms with its dramatic millstone grit background. Today, the rocks are all but obscured by trees and shrubs; what a shame that the county council has the ability to impose road changes that many people say that they don't want, and yet apparently can't maintain a spectacular feature like the rocks that give Wetley Rocks its name. The Masons Arms was situated just where the forecourt of the Total filling station is today.

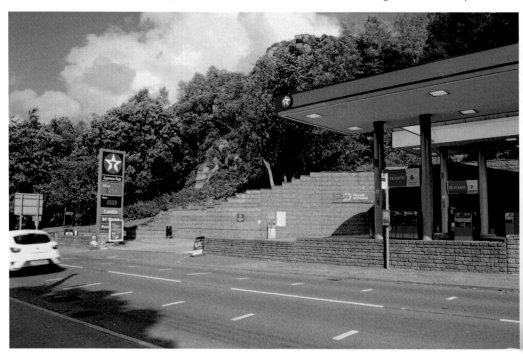

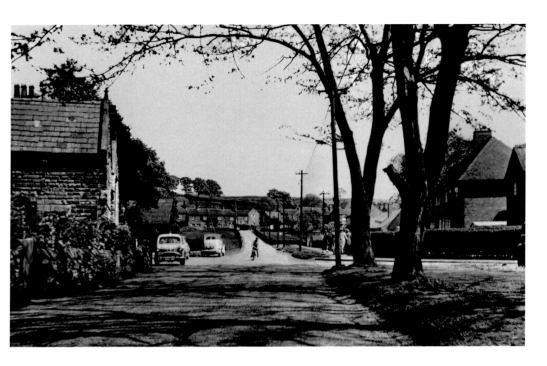

Mill Lane

Mill Lane, in the two photographs, is largely unchanged, apart from the usual growth of trees and increase in the volume of traffic. The recent photograph was taken after many of the local schoolchildren had already been collected, and traffic levels had considerably subsided. Twenty minutes earlier, parked cars were almost entirely obscuring the view of the lane, and the road was clogged by parents' vehicles mingling with the steady stream of agricultural vehicles and four-wheel drives, travelling to and from Westwood Manor, Rownall and other places.

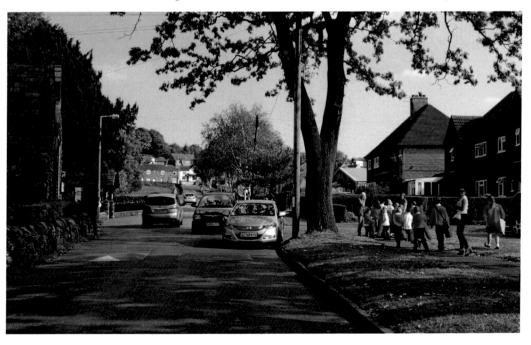

The Crown Inn

The Crown Inn stood in the centre of Wetley Rocks, almost opposite the village water pump, which is still in place today. The Crown is almost unchanged, except that it is now a private house. Annie Chadwick, who was licensee of The Crown when the old photograph was taken, was there between 1891 and 1901 but by 1911, had moved on to the Red Cow at Werrington. Prior to Annie, the licensee was John Austin who was both a quarryman, possibly on 'the rocks', and publican.

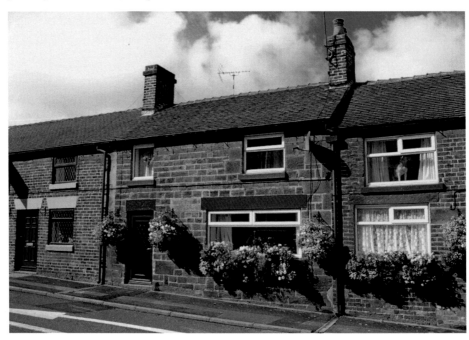

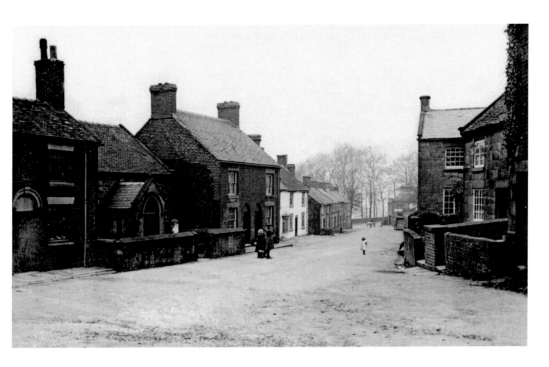

Cheadle Road with Chapel

This view along Cheadle Road towards Cheddleton shows a number of interesting Wetley Rocks buildings. On the left is the 1841 Wetley Rocks Methodist chapel (*see following page*), and further along, although apparently not displaying a sign, is the Crown Inn (*see previous page*). The third building on the right was also a Methodist chapel and beyond that, marked by the presence of an upended cart, was Wood Brothers who were wheelwrights, wainwrights, and blacksmiths.

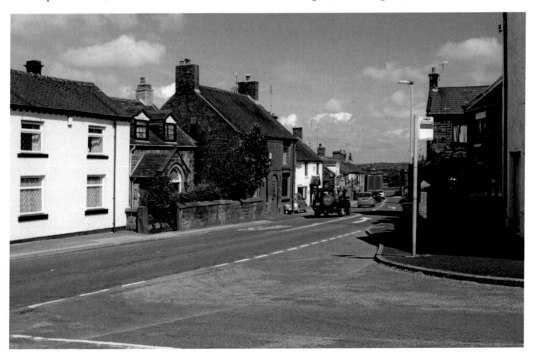

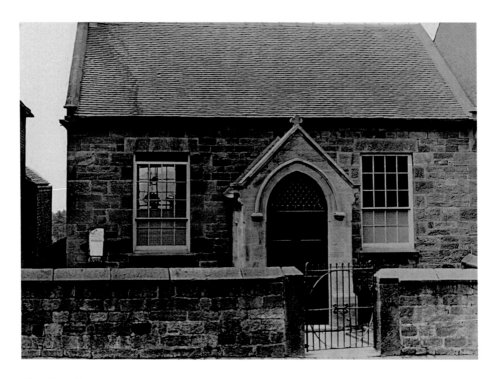

The Chapel

The small single-storey chapel on the West side of Cheadle Road was built in 1841, and following its closure, was converted into a private house. The top third of the original windows have been filled in to allow an upper floor to be added. To light this new floor, three dormer windows have been built in the roof. The work has been done sympathetically, and the house today still retains its quaint chapel appearance.

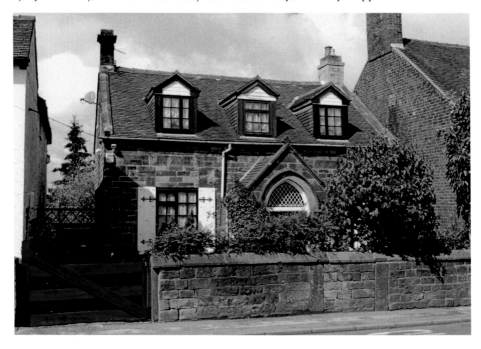

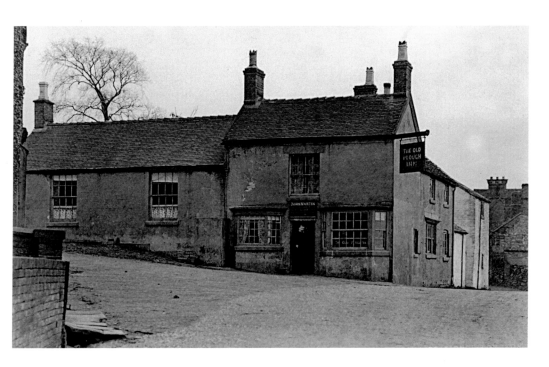

The Old Plough Inn

The photographs here do not show the same building; the old premises having caught fire in 1945 and being completely gutted, except for one room. To retain the license, this room became the pub until it was rebuilt in the 1950s, and The Plough was still serving pints well into the twenty-first century. The boundary line between Wetley Rocks and Consall runs right through the middle of the property, and when 'beating the bounds' is carried out, scaling the roof is necessary to do the job properly.

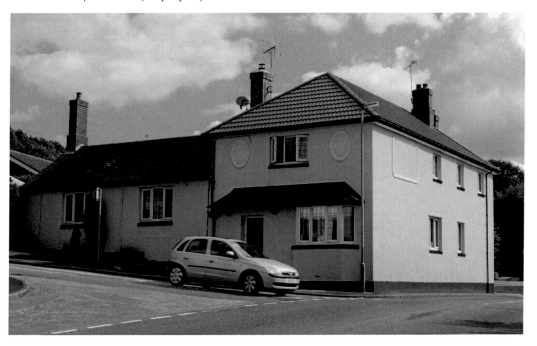

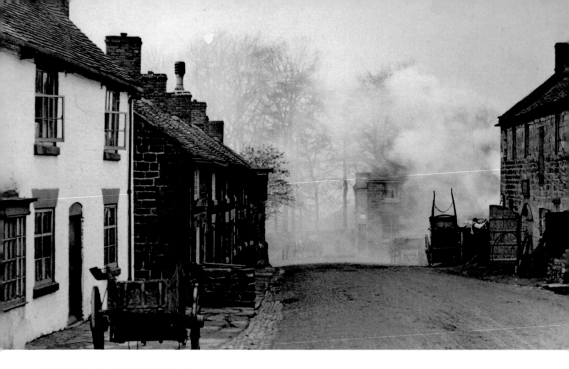

The Wheelwright's Workshop

Another view through Wetley Rocks towards Cheddleton. This one clearly shows The Crown Inn's pub sign on the left. Most interesting though, is the large cloud of steam drifting across the road from the building on the right. Here was a workshop, where several different activities were carried out; theoretically Wood Brothers were wheelwrights, but they also made carts and did general forge work. The steam is probably from 'quenching' a metal rim in water in order to contract it on to a wooden cart wheel.

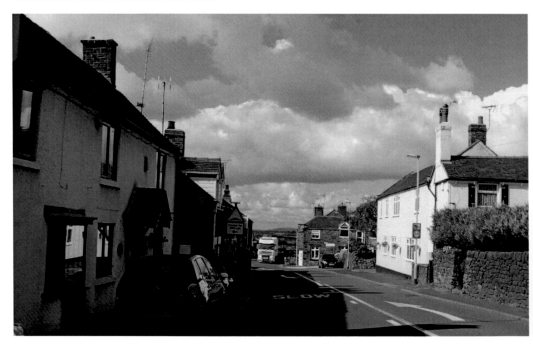

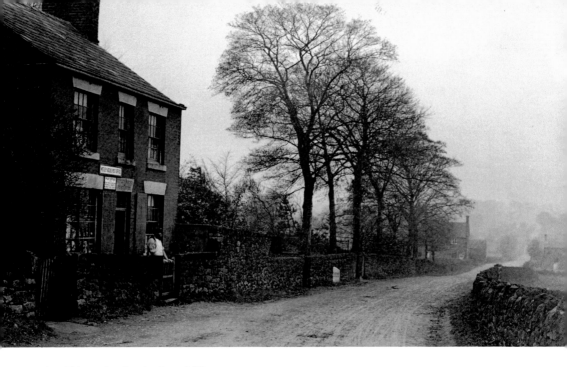

The Old Wetley Rocks Post Office

The old post office stood, and indeed still stands, on the Cellarhead side of the Plough Inn. So good is the quality of some old photographs that above the door one can read: 'Wetley Rocks Post Office', along with 'Post Office for Money Orders, Savings Bank, Parcel Post, Insurance & Annuity Business'. Like many post offices today, the Wetley Rocks branch also sold domestic items such as teapots, chocolate and cigarettes. Wetley Rocks no longer has a post office since the one on Plough Bank closed.

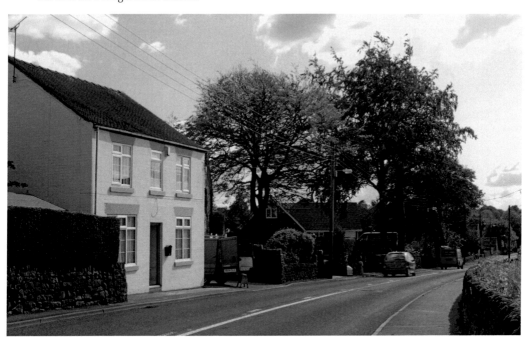

Gentlemen's Residences

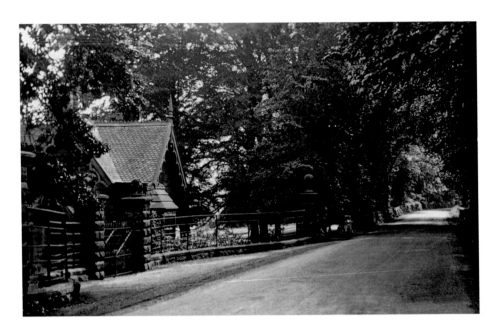

Ashcombe Park Lodge

This lodge stands guard over the drive from Cheadle Road to Ashcombe Park, and bears the Sneyd scythe on a shield above the door. The gateposts used to be topped by a pair of stone lions, one of which allegedly had its tail shot off with an air rifle by the grandson of a couple who lived there. Sadly, the lions have now gone. The lodge is currently unoccupied, but it is to be hoped that it might be brought back into use soon.

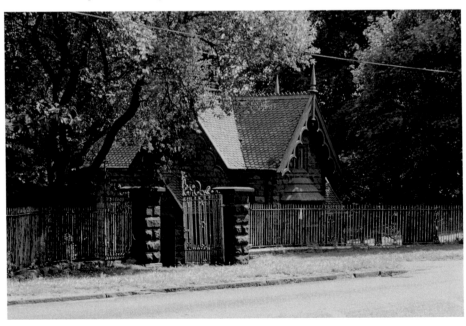

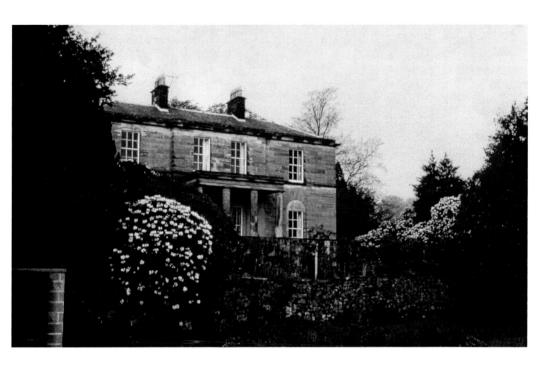

Ashcombe Park, 1973

William Sneyd married Jane Debank, who inherited her family's Elizabethan mansion house, Botham Hall. William had Botham taken down and employed James Trubshaw Junior to build Ashcombe Park between 1807 and 1811. Ashcombe is built of Ashlar, finely cut and dressed stone, rather than rubble masonry, in which irregular stones are liberally mortared together and then hidden by stucco. The house of two storeys and three bays has a three-bay porte-cochère (coach porch), believed to have been transported from Belmont Hall.

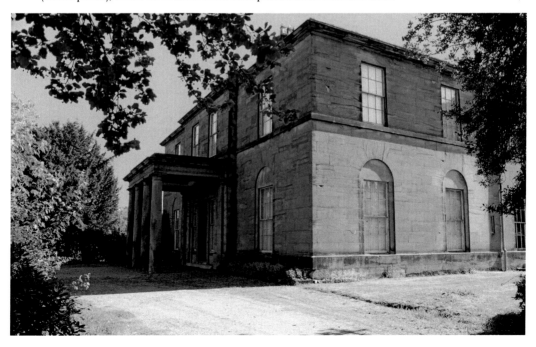

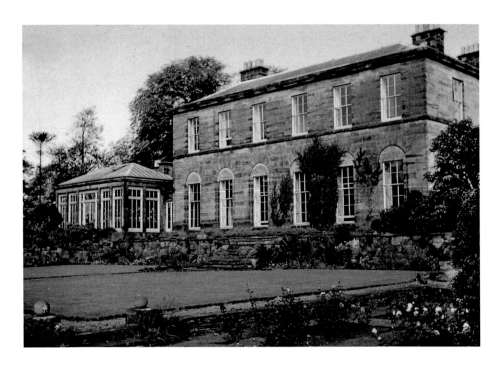

Ashcombe Park, South Front, 1964

The Sneyds sold Ashcombe in 1936, and it has seldom changed hands since then. It has been the home of the Wardles (silk manufacturers), and John Haigh of Brittain's paper mill who bought it in 1960 intending to live in it, but also to sell building plots along Ashcombe Level. This plan had to be abandoned when planning consent was refused. The house changed hands for the last time early in 2014, and the parkland is now to be used for the rearing and shooting of game birds.

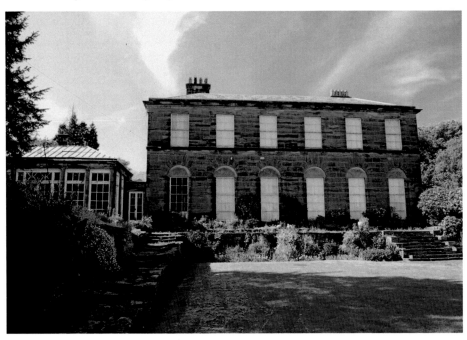

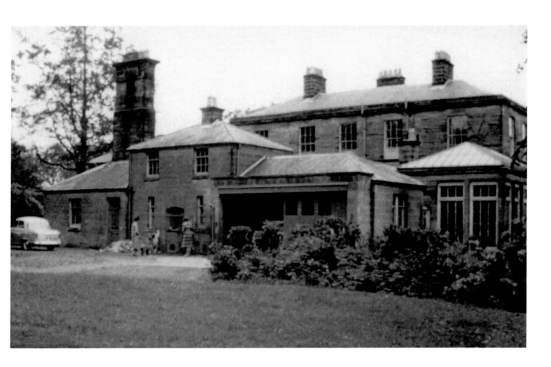

Ashcombe Park Rear

These photographs show the rear of Ashcombe Park with its huge chimney serving the kitchen, the garage and the end of the orangery, added by Revd John Sneyd in the 1850s. Revd Sneyd had moved into Ashcombe in 1851, following the death of his father William the previous year. Also visible are the kennels, probably once used to house sporting dogs such as pointers and retrievers. Perhaps these will soon be used again for the same purpose, when the estate becomes a centre for shooting.

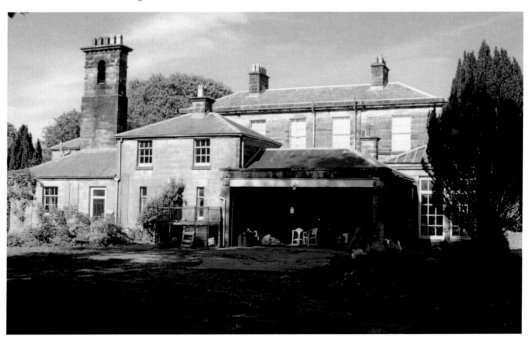

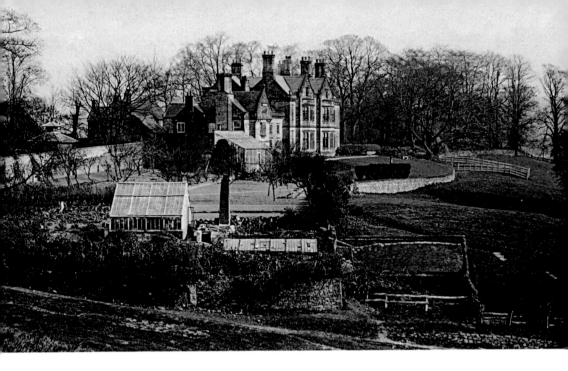

Basford Hall

This house began as two large farmhouses incorporated together around 1794, to become the first Basford Hall. The property suffered a fire in 1805, and two periods of disuse so that, by 1827, it was already rather dilapidated. The Revd John Sneyd, who had been buying and selling houses as often as he changed his clothes, bought it from his father and demolished parts of it. He then employed architect James Trubshaw Jnr, who had built Ashcombe Park, to design and build a new Basford Hall.

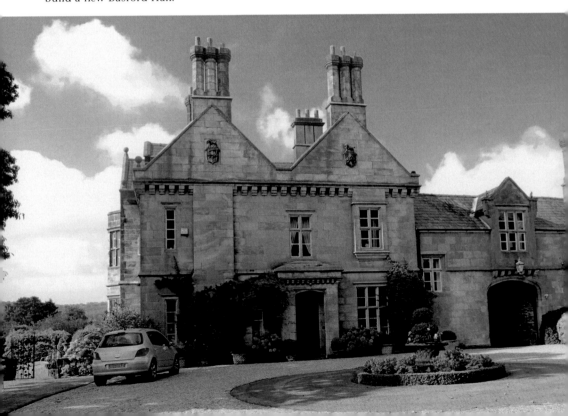

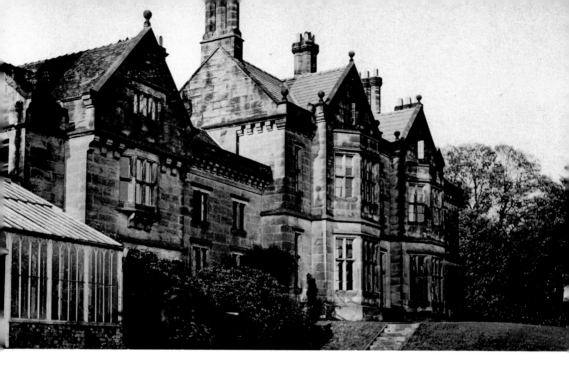

Basford Hall
Revd John Sneyd moved back into Basford Hall in 1829 and, in 1830, the new Basford Hall was finally completed. This house though also suffered periods of neglect because as soon as William Sneyd died, Revd John and his family moved from Basford to Ashcombe. At one time, Basford was used as a school. It was also converted into flats. It has since been lovingly restored by the present owner, who is descended from the Sneyds through the maternal line.

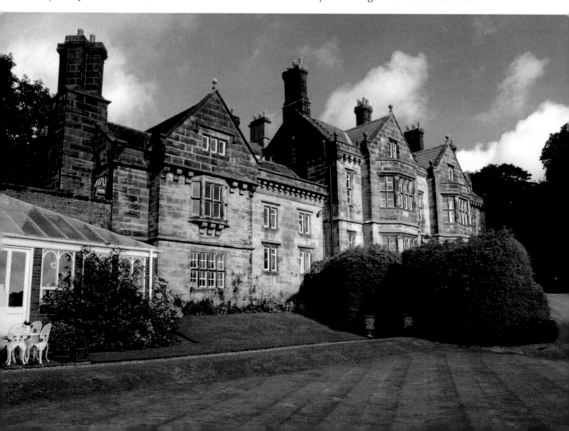

Basford Hall Bath House

Basford Hall's bath house was built by Revd John Sneyd who referred to it as his 'castle'. This is perhaps not surprising, given that he adorned the house with a large circular turret and built a second nearby. The only old photograph known of the bath house is the postcard seen here, which fails to do justice to this beautiful building. The tiny cottages visible between the house and the turret have since been demolished, their stone being used to restore other old buildings on the estate.

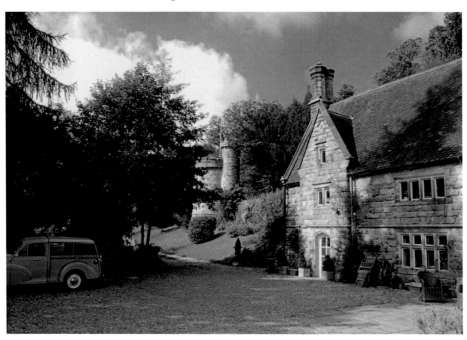

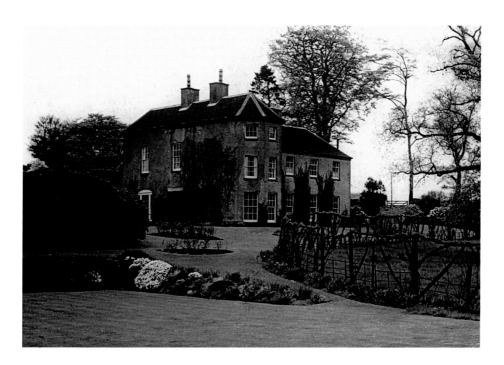

Belmont Hall

Belmont is the oldest of the 'Sneyd Houses', having been built for John Sneyd between 1760 and 1770. It is believed that a large section of the mansion was demolished around 1806, and foundations discovered under the gardens to the southwest, coupled with the false fenestration on what is now the approach front, suggest that there was originally a large wing here balancing the one running nort-eastwards. The porte-cochère, now at Ashcombe Park (1807–11), is believed to have been transferred there from Belmont Hall at this time.

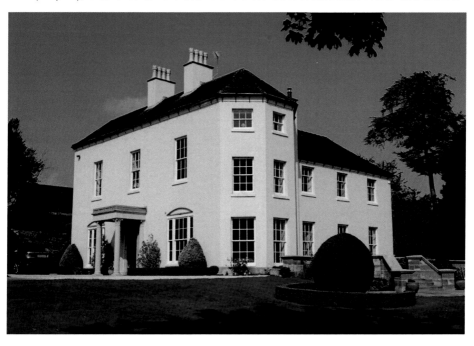

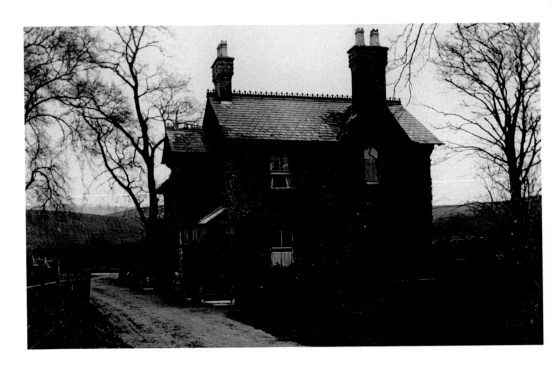

Basford Hurst Lodge

The history of this cottage, or rather pair of cottages, is more complicated than it might at first seem. Basford Hurst was built around 1861, and Churnet Grange, which appears to be in Basford Hurst's grounds, some twenty years later. In fact, Basford Hurst was built in the grounds of the forerunner of Churnet Grange and, as recently as 1911, there were two Churnet Grange lodges and no Basford Hurst lodge. The lodges may have been bought by Basford Hurst or may have just been adopted.

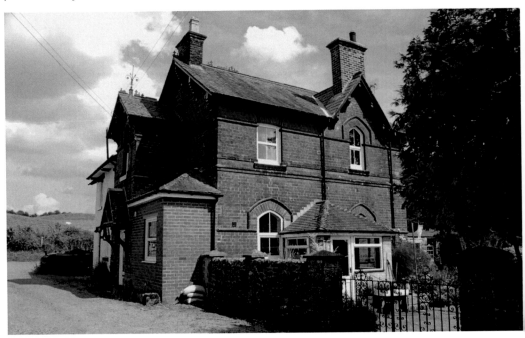

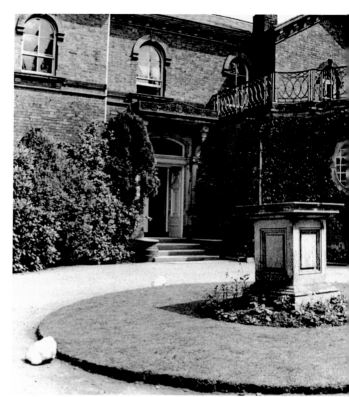

Basford Hurst Front Entrance
Basford Hurst was apparently built around 1860 for Edwin Heaton, a land agent. William Henry Rider, silk manufacturer, whose initials are still carved above the front door, occupied the house between the 1890s and his death in 1909. When Mrs Rider died in 1932, having lost both her husband and son within two years, the house was acquired by William Dixon Walker, of Walker's Century Oils. The Walkers remained until 1974 when Basford Hurst was sold again. It is now a nursing home, although the house itself remains largely unchanged.

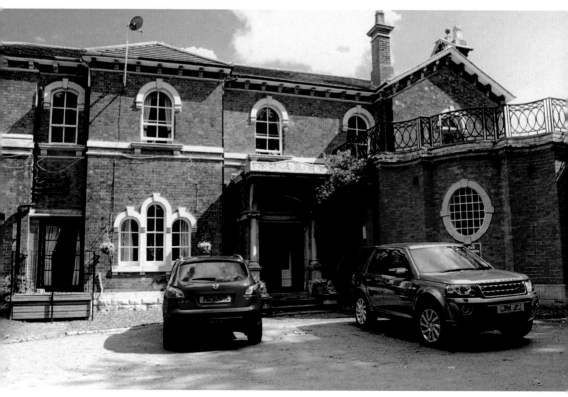

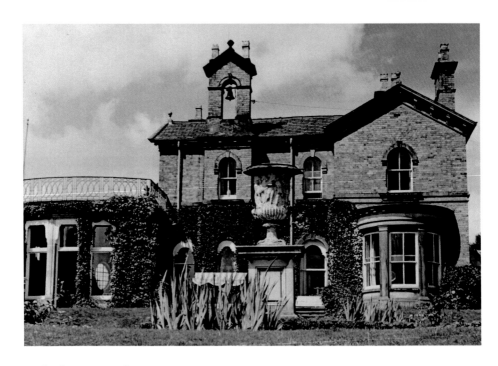

Basford Hurst South Aspect

Basford Hurst has been attributed to the Sugden's of Leek, although it is not known what the evidence is for this. The bell on the side of the house was apparently used to summon the children inside for meals. Today, this scene is much changed, a large part of the garden having been excavated for part of the nursing home. The original garden level was at the bottom of the flight of steps, now ending in mid-air on the new photograph. To the left, was the billiard room.

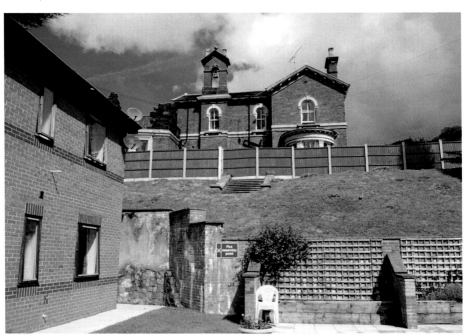

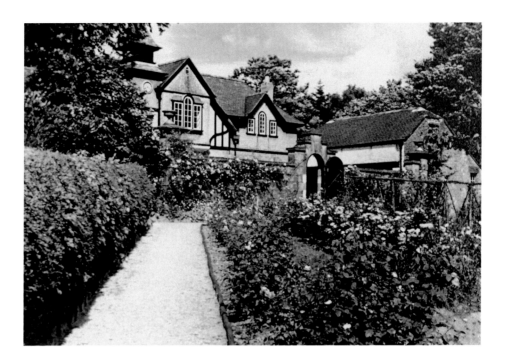

Basford Hurst Cottage

This cottage bears the initials WHR (W. H. Rider) and the date 1908 on a downspout. It housed the garages, stables, sewage pump and electricity generator for Basford Hurst. It also provided living accommodation for the groom and chauffeur. When a light was switched on in the main house, a battery-fed signal travelled along a cable to the cottage starting the generator. The light would then come on – only a minute or so after flicking the switch. The cottage has lost its garden, but is nevertheless an attractive private house.

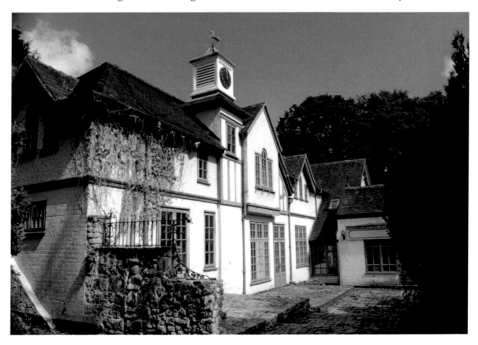

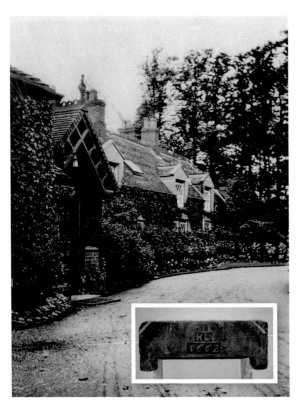

Churnet Grange

Churnet Grange was built in the late nineteenth century on the site of a house known as Old Basford, then Basford Villa. Captain A. H. A Colville (Madras Cavalry) is believed to have demolished Basford Villa and built the nine-bedroom house shown here. For some reason in the twentieth century, the wing (*shown here*) was demolished. Inside the old kitchen today, a stone above the fireplace is inscribed J. H. L. (Joan Leech) 1662, presumably the date stone from Old Basford. This stone is just visible above a downstairs window in the old photograph.

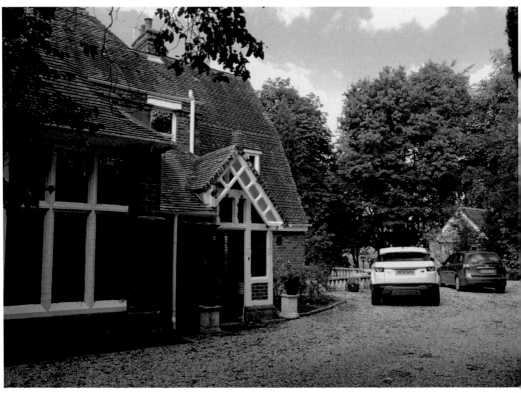

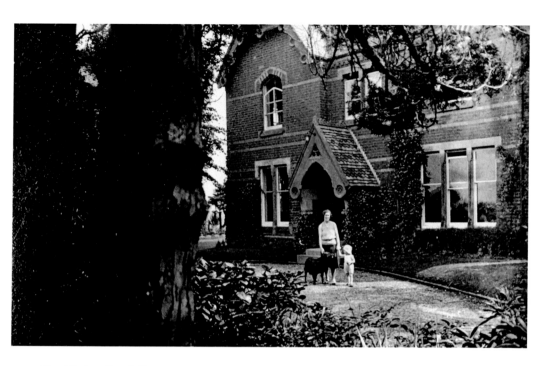

Cheddleton Heath House

Cheddleton Heath House, with its tower, stands at the end of Cheddleton Heath Road and is highly visible to walkers and drivers travelling from Leekbrook toward Cheddleton. The old photograph shows the present owner as a toddler, with his mother on the drive outside the main entrance to the house. This drive has now been covered in grass and the door abandoned. It may have been the Wardles who built the house, because it would have allowed them to keep an eye on their dye works when they were at home.

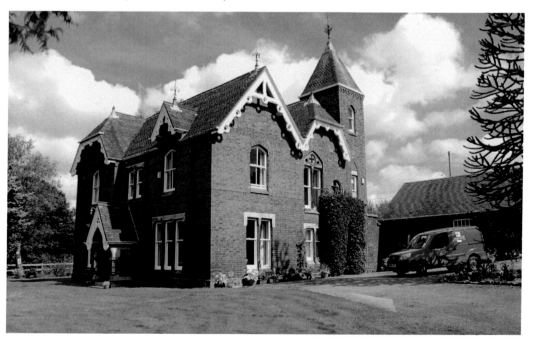

Heath House

Now known as Heath House Farm, the house is predominantly a late eighteenth or early nineteenth-century gentleman's house with a later extension and porch, both visible on the recent photograph. Alfred Francis Boucher, the vicar of Cheddleton, lived at Heath House between the 1860s and 1880s but, by 1891, had retired to Kempsey, Worcestershire. His son, Alfred Herbert, took over as vicar, but he moved from Heath House into the newly built vicarage, adjacent to Cheadle Road (*see pages 44–46*).

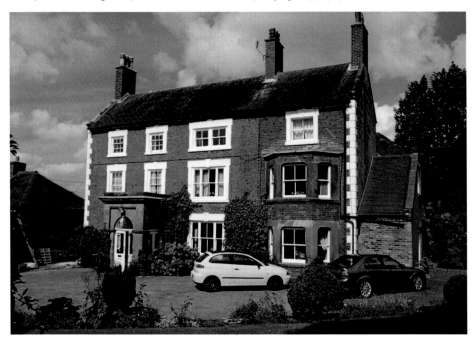

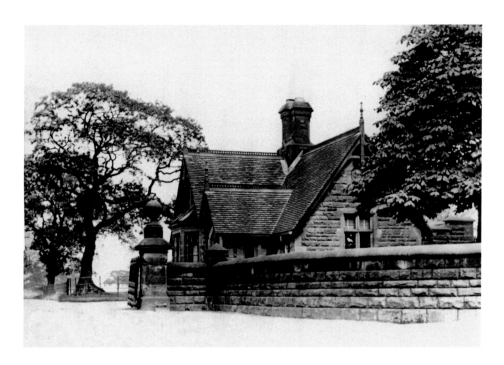

Westwood Manor Lodge

The gate lodge to Westwood Manor, located at the bottom of Mill Lane, was built along with the manor for potter, William Meakin, in the 1870s. As with the manor, the lodge carries its date of building in the gable, but this is no longer visible because of the screen of trees, which now conceal much of the building from view. It is not yet known whether there was an earlier lodge here for Westwood House, the predecessor to Westwood Manor.

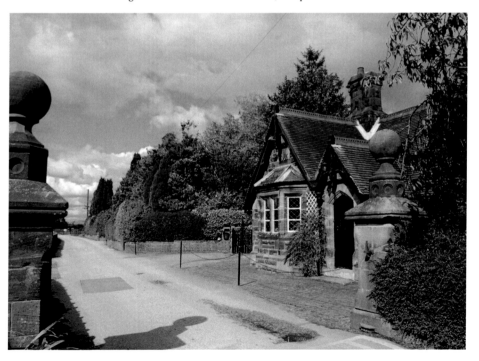

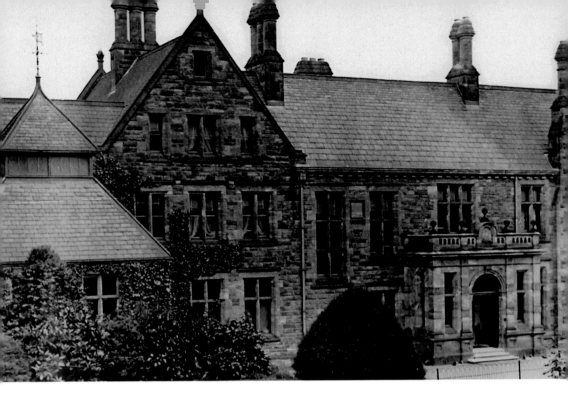

Westwood Manor, West Front

Westwood Manor is a very large house in the Elizabethan style that replaced Westwood House. Westwood House had belonged to both the Arblaster and Powys families, who between them had been lords of the manor of Cheddleton for 250 years. Westwood Manor was built in 1878 for pottery manufacturer William Meakin. In 1944, Enoch Haughton, a former auctioneer and pianoforte dealer, donated the house to Stoke-on-Trent to be used as a school. It was named the Cicely Haughton School in memory of Mr Haughton's late wife.

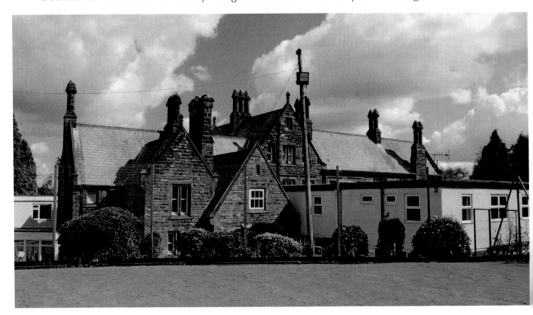

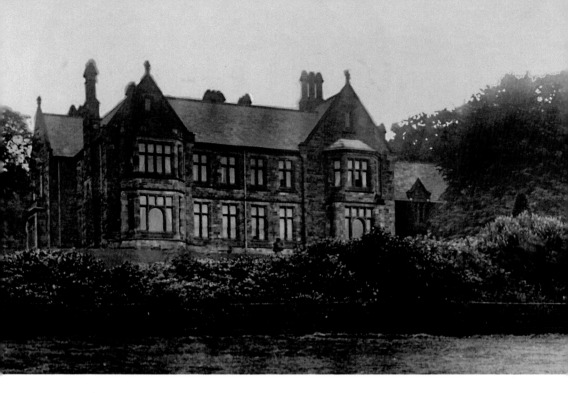

Westwood Manor, East Front

Westwood Manor was a beautiful house of red sandstone situated on a hillside, with far-reaching views of Cheddleton and Wetley Rocks. Sadly, since becoming a school, the house has been treated most unsympathetically on every side. Its fine main entrance bearing William Meakin's initials above the door has been constrained inside a small courtyard, and the house is beset, both by modern extensions, and sports facilities at both front and rear. At least most of the east-facing front, visible from Cheadle Road, has remained largely as built.

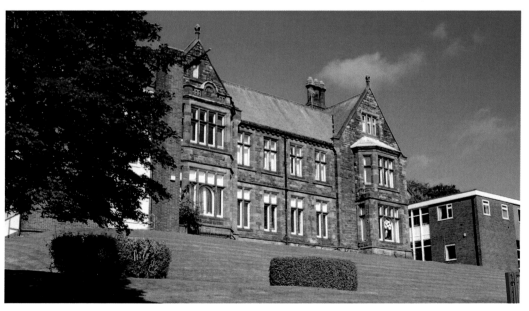

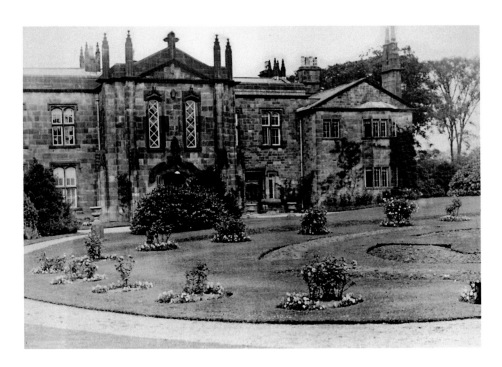

Wetley Abbey

Reputedly built in 1824 for potter George Miles Mason, part of the building appears different and may be slightly older. It was never a religious establishment, merely following a romantic whim of the time. When G. M. Mason died, the house passed to his artist son, George Heming Mason RA. G. H. Mason died in 1872, and the house then passed through a number of hands including Frank Swynnerton, the caterer. Latterly, it became a nursing home and was extended. Now in private ownership, the exterior has been painstakingly restored.

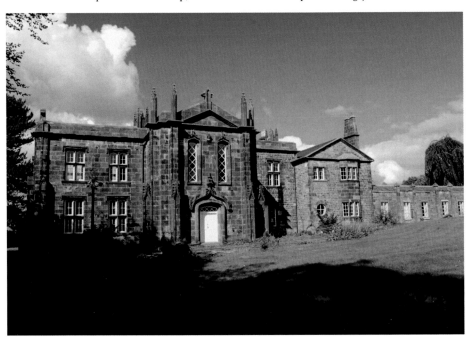

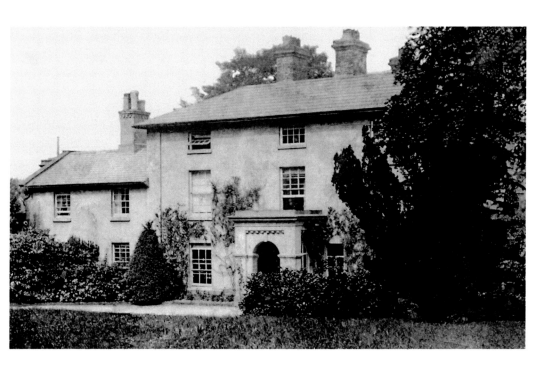

Woodlands

Woodlands is another large house, which formerly belonged to the Sneyd Family, who also owned and occupied Ashcombe Park, Basford Hall, Belmont Hall and Sharpcliffe Hall at various times. Built in 1832, it was a near neighbour to Ashcombe Park reached via a private drive on which are located various cottages and outbuildings formerly housing gamekeepers. Today, it is apparently owned by John Pointon & Sons, whose business is located nearby, and is undergoing extensive restoration.

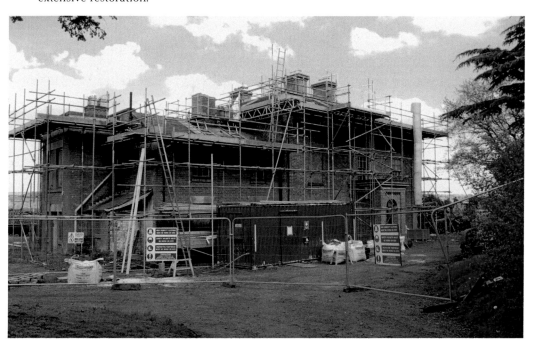

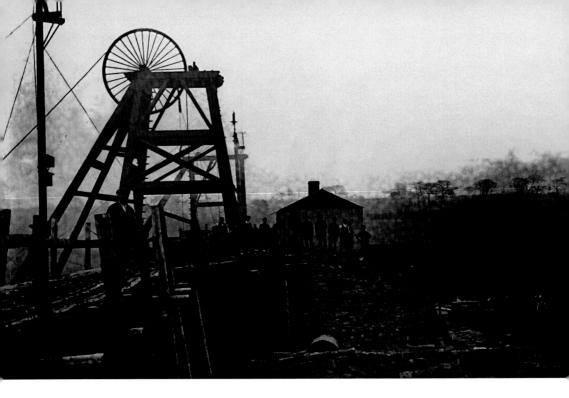

Shaffalong Pit

There have been several coal mining operations in the Shaffalong area, the last of these commencing in 1906. Unfortunately, two shafts having been dug, one to a depth of 600 feet. Flooding rendered them unworkable and the pit was abandoned in 1908. The old photograph shows the winding gear at this last pit, and the recent photograph shows one of the fenced-off shafts. The inset shows the huge, thick concrete slab that was used to cap the top of the shaft.

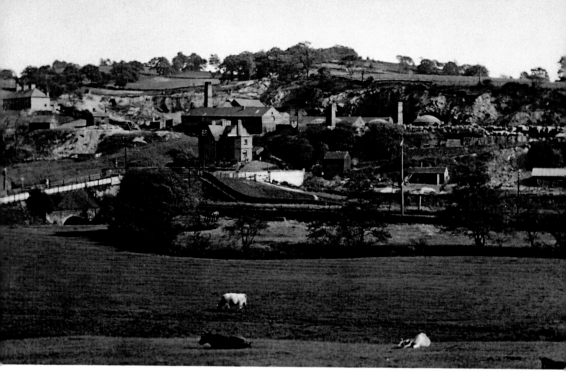

Wall Grange Brickworks

The fascinating old view shows the vast Wall Grange Brickworks at the foot of Park Lane. The photograph invites intensive study, and may still reveal something new to see. There are the vast outcrops of clay, beehive ovens and the fired bricks ready to be carried away via the canal. The brickworks' manager's house (*see next page*) can be seen with the canal and railway bridges, signals, carts and a tributary of the River Churnet. On the recent photograph, all that is visible are trees and just a glimpse of the manager's house.

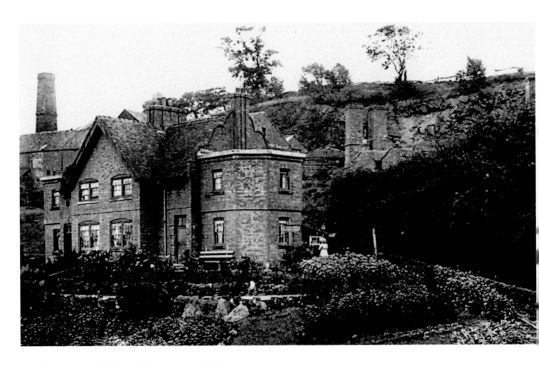

Wall Grange Brickworks' Manager's House

Wall Grange Brickworks probably began production around 1850, and continued until 1960. It once employed nearly forty men, but suffered financial difficulties and changes of ownership throughout its history. Clay used in the works was initially easily extracted, but once the outcrops were exhausted, it could only be reached after removing 50–60 feet of sandstone from above the seams. These photographs show the pair of large stylish houses, one of which used to be occupied by the brickworks' manager.

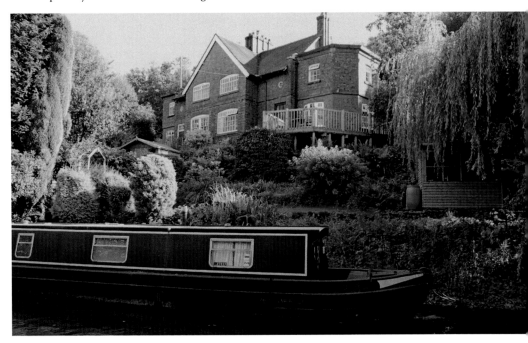

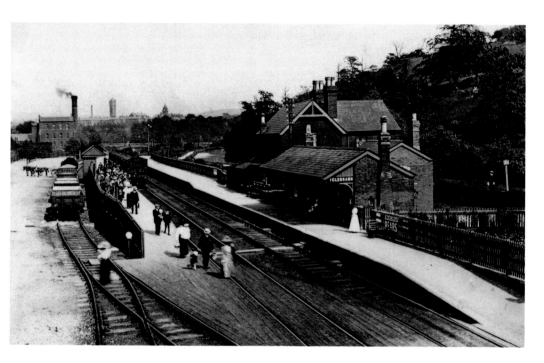

Wall Grange Station Double Track, *c.* 1910

This is one of the most dramatically changed pairs of pictures in the book; in the old photograph a large number of people, dressed in their Sunday best, alight at the North Staffordshire Railway's Wall Grange station from a train bound for Cheddleton and beyond. In the background is Wall Grange pumping station and, beyond that, the huge County Asylum. Today, one platform and the stationmaster's house, concealed among the trees, survive next to a single-rail track, currently unused.

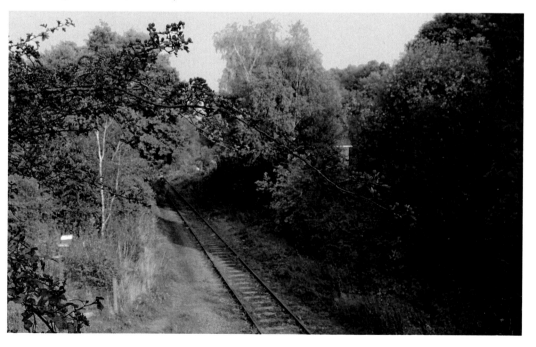

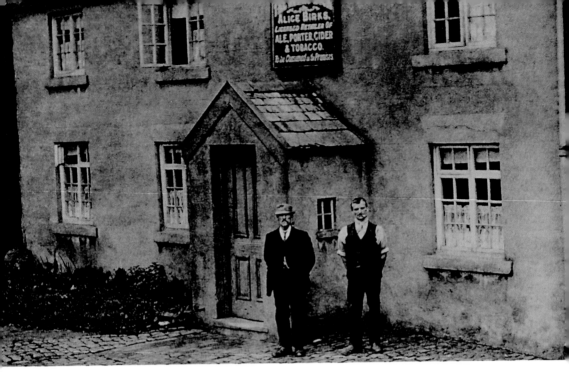

The Holly Bush, Denford

When Alice Birks was licensee of the Holly Bush at Denford, little would she have imagined how popular or how much bigger the establishment would become in the future. The Hollybush has the advantage of being accessible on foot, by car or from boats navigating the Caldon Canal, which passes immediately in front of it. On a sunny summer's day, the place is heaving with customers and serves copious amounts of food and drink. The sign for Cheddleton stands by the entrance to the car park.

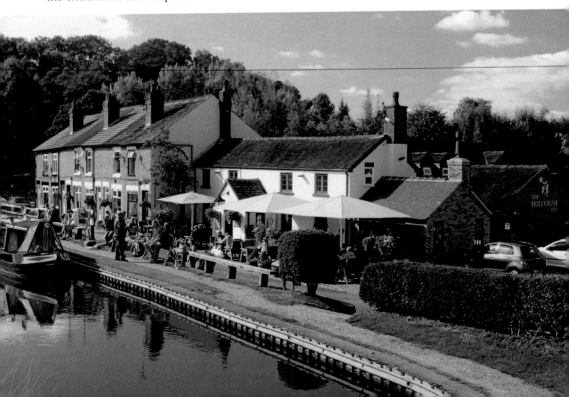